SURVIVAL

manual

designer's

survival

manual

HOW
DESIGN
BOOKS
CINCINNATI, OHIO
www.howdesign.com

POPPY EVANS

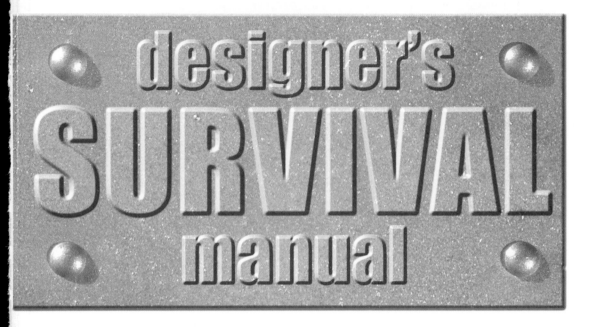

➤➤ **THE INSIDER'S GUIDE TO WORKING WITH**

illustrators,

photographers,

printers,

Web engineers and more...

Visit www.howdesign.com for information on more resources for graphic designers. Other fine HOW Design Books are available from your local bookstore, art supply store or direct from the publisher.

05 04 03 02 01 5 4 3 2 1

Library of Congress Cataloging-in-Publication Data
Evans, Poppy
 Designer's survival manual : the insider's guide to working with illustrators,
 photographers, printers, Web engineers, and more ... / Poppy Evans. — 1st ed.
 p. cm.
 ISBN 1-58180-125-4 (alk. paper)
 1. Graphic design (Typography)—Handbooks, manuals, etc. I. Title.

Z246 .E93 2001
686.2'252—dc21 2001016938

Editor: Clare Warmke
Designer: Lisa Buchanan
Production Coordinator: Sara Dumford
Cover Photography: Comstock, Inc. (www.comstock.com)
Additional Photography: Christine Polomsky

The credits and permissions on page 176 and throughout
the text constitute an extension of this copyright page.

Special thanks to those publications that permitted the use of text excerpts:

The Bell Press Guide to Scitex Prepress
Bell Press
49 Ralph St.
Belleville, NJ 07109

Via Basics: Binding, The Gospel According to Glen and "Creation" brochure
designed by Higashi/Glaser, New York
Hammermill Papers
6400 Poplar Ave.
Memphis, TN 38197
www.ipaper.com

HOW magazine
1507 Dana Ave.
Cincinnati, OH 45207
www.howdesign.com

Graphic Communications Trade Customs and Business Practices
Printing Industries of America (PIA)
100 Dangerfield Rd.
Alexandria, VA 22314
www.gain.net

Publish magazine
462 Boston St.
Topsfield, MA
01983-1200
www.publish.com

The Warren Standard
Sappi Fine Paper North America
8201 Corporate Dr., Ste. 570 Landover, MD 20785

Step-By-Step Graphics
6000 N. Forest Park Dr.
Peoria, IL 61614-3592
(800) 255-8800
On Press With Success
Strathmore Paper Co.
135 Center St.
Bristol, CT 06010
www.ipaper.com

U.S. News & World Report Stylebook: A Usage Guide for Writers and Editors
U.S. News & World Report
450 W. 33rd St., 11th Fl.
New York, NY 10001
www.usnewsproducts.com/gen-edprod.cgi

And these titles from North Light Books:

2000 Artist's & Graphic Designer's Market

Getting It Printed, by M. Beach and E. Kenly

Graphic Artists Guild Handbook: Pricing & Ethical Guidelines, 11th edition

Graphic Designer's Guide to Faster, Better, Easier Design & Production, by P. Evans

How to Find and Work With an Illustrator, by M. Colyer

Self-Promotion Online, by I. Benun

This book is dedicated
to my parents
Bill and Letha Evans
and to my son
Evan MacVeigh.

ABOUT THE AUTHOR

Poppy Evans

Poppy Evans is a freelance graphic designer and writer who has been working from her Park Hills, Kentucky, studio since 1991. Prior to forming her own business, she served as managing editor for *HOW* magazine and art director for *Screen Printing* and *American Music Teacher* magazines. In addition to this book, she has authored nine other titles and is a frequent contributor to many design magazines. She is also on the faculty of the Art Academy of Cincinnati, where she teaches in the school's Communication Arts program.

ACKNOWLEDGMENTS

I would like to thank Lynn Haller for asking me to write this book, editors Linda Hwang and Clare Warmke for their guidance in assembling content, Sara Dumford for guiding this book through production and Lisa Buchanan for her interior and cover design.

TABLE OF
>> CONTENTS

TABLE OF CONTENTS

INTRODUCTION

➤ ➤ Have you ever had a job turn out less than perfect because the paper you chose was wrong or experienced color that wasn't as accurate as you'd hoped? Maybe you noticed that a photograph was out of focus after your piece was printed. Or perhaps you've experienced every designer's worst nightmare—the "typo" that was missed in the client's name, address or phone number.

➤ ➤ If you're saying to yourself, Been there, Done that, you're not alone. Most designers make these kinds of mistakes during the course of their careers. Although these accidents become less frequent with increased experience, they still occur because we depend so much on the services of others for the successful completion of a project.

➤ ➤ It's easy to blame the paper, the printer, the photographer or the copywriter when things don't turn out exactly as you'd hoped, but the reality of the situation is that designers need to anticipate problems and work with their vendors to prevent accidents.

➤ ➤ This book was designed to do just that. It contains advice from technicians and other creative professionals, including photographers, illustrators and writers, as well as seasoned designers who offer their insights into how to work effectively with others. There's advice on how to negotiate the best deals and work together to arrive at the most economical solutions. You'll also find lots of technical tips on how to prepare your jobs so there won't be problems when your work is given to a service bureau, printer or Web technician.

➤ ➤ This book starts with the written word, the basis of all design projects, with tips from writers. From there, it's organized according to each phase of production and the vendors involved in that phase—from incorporating illustration and photography to getting the job printed or posting it on the Web. You can follow the book in this progression or browse at random. Every page contains at least one useful piece of information that's bound to help you work more efficiently and effectively.

...WRITERS

CHAPTER ONE

1

►► Tips from editors and writers on producing accurate copy,

plus typographic techniques that will help enhance text

and ensure that it's as reader friendly as it can be.

MINI-INDEX

PREPARATION

➤➤ ## PROOFREADING
Get a New Set of Eyes

Have somebody who hasn't been involved in the project proof copy for you. Nothing is more valuable than a fresh set of eyes.

Gordon Mortensen, Mortensen Design, Mountain View, California

➤➤ ## SPELLING
Geographic Atlas to the Rescue

Consulting a spell checker and dictionary will do for the spelling of most words. But when it comes to proper nouns, keep a geographic atlas on hand to check for the proper spelling of states, cities, countries and international municipalities.

➤➤ ## BRAINSTORMING
Nix the Naysaying

When we collaborate and steer ourselves toward a common goal, our energies must be channeled constructively. The success of any brainstorming session depends upon all members understanding the importance of creating a positive environment. To encourage this, avoid making negative judgmental statements about ideas, such as:

- It's against our combined logic.
- It can't be done.
- Someone has probably already tried it.
- You're on the wrong track.
- The market isn't ready yet.
- Not enough return on investment.

Whenever someone in the group says, "Yes, but...," require him to change it to "Yes, and...," continuing where the last person left off. Whenever someone says, "That idea won't work or can't be done," require that person or group to come up with three ways to make the idea work or get it done.

Excerpted with permission from "Creative Collaboration," by Michael Michalko, *HOW* magazine, April, 2000

➤➤ QUARKXPRESS SHORTCUTS
Add Multiple Words to Your Auxiliary Dictionary

Here's a fun way to add a bunch of words to your auxiliary XPress dictionary, all at the same time. This only works if you've already selected an auxiliary dictionary for your document, of course.

Create a text box with all the words that you want to add to the auxiliary dictionary. Select Check Story from the Utilities menu, and when XPress displays the number of suspect words, click OK. (In this scenario, all the words in the story will be suspect words.) In the Check Story dialog box, hold down Option/Shift (or Alt/Shift) and click the Done button. This elegant shortcut adds all the suspect words to your Auxiliary Dictionary in one fell swoop. If you make a mistake or you want to make sure the words were added, select Edit Auxiliary in the Utilities menu. - Anne-Marie Concepción and David Blatner

Excerpted with permission from "101 Hot Tips," *Publish* magazine, September 1998

➤➤ STYLE SHEETS
Make Final Changes Quickly on a Publication

Taking extra steps at the beginning of a project will save you valuable time in the long run. For instance, creating style sheets for text, subheads and headlines in a publication will help save time at the end of the project when you need to make one of these items a point larger or smaller to accommodate copy changes.

Gordon Mortensen, Mortensen Design, Mountain View, California

➤➤ COPY LENGTH
Should Copy Dictate Design or Design Dictate Copy?

When developing creative for a corporate or product marketing campaign, if I come up with a strong theme or catchy slogan, it becomes the kicker for the design team to work from and can also establish the tone or attitude that they are able to reflect. If we are given a service- or product-specific project, where preliminary writing is not required, then the designer will develop the initial component layouts, positioning the visuals, headings and text blocks so I can write to fit. In print advertising, where your space is restricted to the size of the ad, the layout usually dictates the space allocation for writing, accompanied by specific word counts for headlines and body copy. In most cases with advertising, I have been the source for the creative, developing ideas (in the form of headlines) that are presented to the client. When a choice is made, I'll collaborate with the designer to develop visual approaches that best enhance the message and the impact of the ad. However, when we develop print collateral for a campaign and the studio is responsible for determining and recommending the size, number of pages, etc., I have more freedom to write everything that I feel is necessary to tell the story. Often this copy will cue the designer as to how much weight and position in the

piece to allow for. When we develop the graphic interface for a Web site design project, the designer really dictates the length of copy that will appear on a page.

Stephen Hards, Iridium Marketing + Design, Ontario, Canada

➤➤ BRAINSTORMING
The Best Ideas Come From a Collaboration Between Writer and Designer

Even though Iridium is primarily a design studio, I find that word-based ideas can be a stimulating force in our brainstorming sessions and act as a launchpad for designers to develop visual creative. I think it's very important that everyone on the creative team be flexible and open with their input. As I like to tell the designers, I don't write anything in stone. I am always willing to adapt my words to their design direction and needs.

Stephen Hards, Iridium Marketing + Design, Ontario, Canada

➤➤ COPY LENGTH
How to Persuade a Client or Copywriter to Cut Copy

The best way to make cutting copy less painful is to point out why the graphic message of the piece will get lost if the copy is too long and, at the same time, offer your client some options:

- **Point out that in order to be reader friendly, the type size must be large enough for people to read without squinting or reaching for their glasses.**
- **Headlines, illustrations, photos and other elements are attention getters. To reduce them to make room for extensive copy also reduces the likelihood of capturing a reader's attention.**

Copy can be edited without affecting its meaning. Show an example of how the piece would look with existing copy and how it would look with trimmed copy.

➤➤ PROOFREADING
Don't Hire a Writer to Proofread or a Proofreader to Write

There are editors who specialize in editing and proofreading and there are writers who write copy. The disciplines (and the associated price scales) are very different. Writers should be responsible for delivering clean content, but don't assume that a writer will proofread and edit another's work or that an editor or proofreader will write copy.

Megan Alink, freelance copywriter, Ontario, Canada

>> TERMINOLOGY

Avoid Gender Bias

Consider alternatives to language that emphasizes a person's sex or that implies certain occupations are in the exclusive domain of men or women.

Limiting terms that may be offensive	Possible alternatives
anchorman, anchorwoman	anchor
businessman, businesswoman	businessperson
chairman	chair, chairperson
coed (noun)	student
comedienne	comedian
councilman	council member
craftsman	craftsperson, artisan
fireman	firefighter
fisherman	angler
foreman	supervisor
housewife	homemaker
layman	layperson
mailman	letter carrier
man and wife	husband and wife
policeman, patrolman	police officer
salesman	salesperson
stewardess	flight attendant, steward

Condensed with permission from *U.S. News & World Report Stylebook: A Usage Guide for Writers and Editors*

WRITERS ▶▶
Things to Remember When Working With a Writer

- Have a clear understanding of what each of you expects.
- Determine what the level of involvement will be—whether or not your writer will be involved in meetings and what the level of his or her creative control will be.
- Set a firm deadline with your writer and agree upon a price.

If you think the job will involve additional time because of repeated client alterations, arrange a cost for making revisions.

WRITERS ▶▶
Choose the Right Writer for the Job

Just as illustrators and photographers have different styles and specialties, copywriters specialize in different areas. There are headline people and people who write nothing but text, humorous writers, technical writers, technology specialists, those who specialize in advertising copy and those who do editorial writing. Be sure you hire a copywriter whose expertise is appropriate for the job.

Frank Viva, Viva Dolan Communications and Design, Toronto, Canada

CONTENT ▶▶
Don't Design Until You Understand the Piece's Content

In my industry—high technology—designers are sometimes intimidated by the content for which they're designing. I appreciate a designer who reads what I've written and asks questions in order to understand it. Inevitably, we end up with a better product if the designer is well informed.

Megan Alink, freelance copywriter, Ontario, Canada

WRITERS ▶▶
Where to Find Writers

If you can't find a writer through local contacts, you can get help locating a writer through the Society for Technical Communicators or the International Association of Business Communicators.

➤➤ PUNCTUATION
All Dashes Are Not Alike

Here's the rundown on the different types of dashes available and when to use each:

- Hyphens (-) are the shortest of all dashes and are used to break words when the entire word won't fit on the end of a line of text.

- En dashes (–) are the length of the letter *n* and are used as a substitute for the word "to," as in "May–June." They can be made by hitting Option and then the Hyphen key.

- Em dashes (—) are the length of the letter *m* and are used like parentheses, to set off a sentence fragment. Create them by hitting Option/Shift/Hyphen.

➤➤ NUMBERS
Handling Numbers

In general, spell out cardinal and ordinal numbers below 10. Use figures for numbers 10 and up, unless they begin a sentence; for instance, "Eleven salespersons entered the room."

Adapted with permission from *U.S. News & World Report Stylebook: A Usage Guide for Writers and Editors*

➤➤ COPY LENGTH
Expand Copy With Typographic Treatments that Take Up Space

If the copy you're given falls short of your needs, consider the following:

- Use an extended version of any typeface or expand the horizontal scaling slightly.

- Use a typeface with a high x-height (lowercase characters that are large in relation to uppercase characters). Some common examples are Helvetica Regular, Eurostile, Bookman and Clarendon.

- "Pad" lines of type with extra leading.

- Use all caps.

DISPLAY TYPE
Tips for Setting Optically Correct Headlines

Display type needs to be set optically rather than mechanically and frequently needs to be manually adjusted to read in the most visually pleasing, well-balanced manner. Here are some guidelines to follow:

- When display type is set in all caps, leading should be manually adjusted until it is optically in balance.

- Optically aligning the left-hand edges of several lines of display type requires scooting rounded characters such as O and C so they hang slightly to the left of the vertical alignment of characters such as D and L.

- "Hang" quotation marks so they are in visual alignment with the left-hand margin of flush left type—a bit to the left of where they would normally fall with centered lines of type.

- Break copy with readability in mind but also so that lines balance each other and the final copy is in a pleasing shape.

Strange Places and Very Odd Faces Wherever You Go

Type set as justified left, before adjustment, makes left-hand edges appear to be uneven. Consistent leading makes lines with descenders appear closer to the line below.

Strange Places and Very Odd Faces Wherever You Go

Optical alignment of this headline makes left-hand edges appear to be justified and leading appear to be more consistent.

➤➤ PUNCTUATION

Adjust Parentheses and Hyphens on All-Caps Headlines

Parentheses, hyphens and dashes are proportioned according to where they fall within copy set in upper- and lowercase. They're optically correct when compared to the ascenders and descenders in lowercase type. When set in all-caps type, these punctuation marks tend to be out of whack compared to letter characters.

TOO-LOW
JUST-RIGHT

A similar problem occurs when setting hyphens or dashes as part of an all-caps headline. They will appear lower relative to the size of the surrounding type. Compensate for this with a baseline adjustment.

(WRONG)
(RIGHT)

When set around copy in all-caps, the parentheses will appear to be too high relative to the type. Compensate for this by adjusting their baseline.

➤➤ COPY LENGTH

Setting Text in Different Languages Will Change Its Length

When designing multilingual versions of a piece, work with your copywriter to accommodate differences in the length of copy set in multiple languages. For instance, the Chinese version of a body of text can run 40 percent shorter than the English version. The same text run in German will be 20 percent longer.

➤➤ FOOTNOTES

Footnote Notes

When doing footnotes, use footnote symbols in this sequence:

• (Option/8)
† (Option/T)
‡ (Option/Shift/7)

➤ ➤ # STATE ABBREVIATIONS
How to Handle State Abbreviations

When the name of a state appears as part of a complete mailing address, use the United States Postal Service abbreviation, listed in the second column below. Otherwise, use the traditional abbreviation listed in the third column.

Alabama	AL	Ala.	New Mexico	NM	N.Mex.
Alaska	AK	Alaska	New York	NY	N.Y.
Arizona	AZ	Ariz.	North Carolina	NC	N.C.
Arkansas	AR	Ark.	North Dakota	ND	N.Dak.
California	CA	Calif.	Ohio	OH	Ohio
Colorado	CO	Colo.	Oklahoma	OK	Okla.
Connecticut	CT	Conn.	Oregon	OR	Oreg. or Ore.
Delaware	DE	Del.	Pennsylvania	PA	Pa.
District of Columbia	DC	D.C.	Rhode Island	RI	R.I.
Florida	FL	Fla.	South Carolina	SC	S.C.
Georgia	GA	Ga.	South Dakota	SD	S.Dak.
Hawaii	HI	Hawaii	Tennessee	TN	Tenn.
Idaho	ID	Idaho	Texas	TX	Tex.
Illinois	IL	Ill.	Utah	UT	Utah
Indiana	IN	Ind.	Vermont	VT	Vt.
Iowa	IA	Iowa	Virginia	VA	Va.
Kansas	KS	Kans.	Washington	WA	Wash.
Kentucky	KY	Ky.	West Virginia	WV	W.Va.
Louisiana	LA	La.	Wisconsin	WI	Wis. or Wisc.
Maine	ME	Maine	Wyoming	WY	Wyo.
Maryland	MD	Md.			
Massachusetts	MA	Mass.			
Michigan	MI	Mich.			
Minnesota	MN	Minn.			
Mississippi	MS	Miss.			
Missouri	MO	Mo.			
Montana	MT	Mont.			
Nebraska	NE	Nebr.			
Nevada	NV	Nev.			
New Hampshire	NH	N.H.			
New Jersey	NJ	N.J.			

TEXT

Tips for Making Text Reader Friendly

Legibility is the most important factor when setting text. Be mindful of the following.

- Type size should be appropriate to column width. Column widths for text should be in proportion to the size of type. Rule of thumb to follow: Columns should be about forty characters wide for maximum readability.

- Avoid rivers. When word spacing is not tight enough in justified columns of text, large white spaces occur between words and look like "rivers" of white running through columns of text. Rivers tend to disrupt the movement of the reader's eye from left to right.

- Check hyphenation. To avoid rivers in long bodies of justified text or extremely jagged ragged right margins, be sure to use automatic hyphenation.

Citizens Against Apathy is concerned and willing to look for solutions. On June 11, the CAA introduced a program to dismantle apathy. This program was the result of four years of planning by the Anti-Apathy Senate, Anti-Apathy Council and Anti-Apathy Committee. "I think the timing is such that because there have been so many situations that have come up recently they almost make apathetic attitudes acceptable. It's that attitude that there is a certain group of people more apathetic than others and it's all right to accept the apathy of others," said Harris Benjamin, co-chair of the Anti-Apathy Committee.

So many others are also concerned and willing to look for solutions. On June 11, the CAA introduced a program to dismantle apathy. This program was the result of four years of planning by the Anti-Apathy Senate, Anti-Apathy Council and Anti-Apathy Committee. "I think the timing is such that because there have been so many situations that have come up recently they almost make apathetic attitudes acceptable. It's that attitude that there is a certain group of people more apathetic than others and it's all right to accept the apathy of others," said Harris Benjamin, co-chair of the Anti-Apathy Committee.

To avoid rivers like these, make sure letter spacing is tight. Rivers tend to occur in justified text when leading is equal to word spacing, causing white space to appear as "rivers" through text. (This sample was set in Times Roman 9/12.)

● ● ● ● ● ●

➤➤ ## LEADING

Know How to Adjust Leading to Improve Legibility

Leading is the distance between lines of type. Standard leading is generally 1 to 2 points larger than the size of the typeface. It's important to use extra leading to improve legibility in the following situations:

- When working with column widths of more than forty characters.
- When using typefaces with a tall x-height.
- When using typefaces with a strong vertical thrust.
- When using a sans serif typeface.
- When setting text larger than normal (e.g., a typeface normally requiring 2-point leading at 10 point will read better at 14 point with 3-point leading).
- When setting text smaller than normal (e.g., a typeface normally requiring 2-point leading at 10 point will read better at 7 point with 3-point leading).
- When setting reversed text.

➤➤ ## TEXT

Using Reversed Type

- Avoid typefaces with thin-lined serifs. In smaller sizes, rule out serif typefaces altogether. Chances are pretty good that when your job is on press, the thin lines of your serifs will fade into oblivion in the dark recesses of your background color.
- In larger sizes, as in a headline, thin-lined sans serifs will work, but avoid them in smaller sizes. In general, the bolder or heavier your typeface, the more assured you will be of having a legible reverse.
- Avoid large areas of reverse text. Studies have shown that you'll lose 20 percent of your readers when you set a paragraph in reverse.
- Add extra leading and consider adding extra letter spacing to aid character legibility.

➤➤ ## PUNCTUATION

Guidelines for Hyphenation

Don't use hyphens in:

- Headlines
- Proper names
- Words with fewer than five characters
- The last word of a paragraph
- After just one letter of a word
- Before the final two letters of a word
- A compound word that already contains a hyphen

➤➤ PUNCTUATION

Don't Rely on the Computer for Proper Hyphenation

In type set on the computer, automatic hyphenation will improperly place hyphens in words that double as both nouns and verbs, such as desert, record, progress and present. When determining exactly where to hyphenate a word, always use the dictionary as your guide.

pro-
gress prog-
ress

The computer will automatically hyphenate "progress" as a verb (left). The proper hyphenation for "progress" used as a noun (right) places the hyphen in a different spot.

➤➤ PUNCTUATION

Keyboard Commands for Quick Quote Adjustments

The keyboard quotation marks aren't true single and double quotation marks—they're actually symbols for inch and foot marks. The following keyboard commands will work in standard page-layout programs for creating true open and closed quotation marks:

Option/[= double open quotation marks

Option/Shift/[= double closed quotation marks

Option/] = single open quotation mark

Option/Shift/] = single closed quotation mark

"wrong"
Keyboard quotation marks, often referred to as "dumb quotes," are really inch marks.

"right"
"Smart" or "curly" quotes are true quotation marks.

➤➤ **COPY LENGTH**

Save Space With the Right Typeface

The copy you've been given won't fit your layout? Here are some tips for making type fit a tight situation:

- Use a condensed version of any typeface or reduce horizontal scaling slightly.

- Set type justified rather than ragged right.

- Reduce letter spacing and word spacing slightly.

- Use a typeface with a low x-height (lowercase characters that are small in relation to the uppercase characters). Some common examples are Garamond, Times Roman and Caslon.

- Keep leading to a minimum (1 or 2 points).

Avant Garde 10/12

Citizens Against Apathy is concerned and willing to look for solutions. On June 11, the CAA introduced a program to dismantle apathy. This program was the result of four years of planning by the Anti-Apathy Senate, Anti-Apathy Council and Anti-Apathy Committee. "I think the timing is such that because there have been so many situations that have come up recently they almost make apathetic attitudes acceptable. It's that attitude that there is a certain group of people more apathetic than others and it's all right to accept the apathy of others," said Harris Benjamin, co-chair of the Anti-Apathy Committee.

Times Roman 10/12

Citizens Against Apathy is concerned and willing to look for solutions. On June 11, the CAA introduced a program to dismantle apathy. This program was the result of four years of planning by the Anti-Apathy Senate, Anti-Apathy Council and Anti-Apathy Committee. "I think the timing is such that because there have been so many situations that have come up recently they almost make apathetic attitudes acceptable. It's that attitude that there is a certain group of people more apathetic than others and it's all right to accept the apathy of others," said Harris Benjamin, co-chair of the Anti-Apathy Committee.

With its high x-height and rounded character, a block of text set in Avant Garde (left) takes up much more space than the same block of text set in Times Roman (right).

➤ ➤ **TEXT**

Convert Word-Processed Documents to "Text Only"

When you save a word-processed document, it will automatically save to the file format of the application you're using. This will limit your ability to work with text in a multiplatform environment and with a variety of programs. To ensure that text will flow smoothly into a page layout program, make sure word-processed copy is saved in a generic format called "ASCII" text. This can be done by selecting Save As and saving the document as a "text" or "text only" file.

Most word-processing programs will let you save a document as "text" or "text only."

FINISHING TOUCHES

➤➤ ## TEXT
Checklist for Acceptable Text Standards

Check typed columns of text for the following before you hand them off for review by the client or copywriter:

- Proper hyphenation: Three lines of text in a row ending in hyphens, proper nouns or other words broken awkwardly, etc.

- Even word and letter spacing in justified type: Watch out for rivers, poor readability.

- Ragged rights that aren't too jagged: Hyphenate words if you find many of your ragged-right lines come up shorter than three-quarters of your maximum line length.

- Orphans and widows: Everyone determines his or her own tolerance level, but there are rules of thumb. If a word stands alone as a line of type at the end of a column, make sure it is a complete word and contains at least five characters. Avoid stranding a word or short line at the top of a column before a paragraph break.

- Paragraph breaks: Indentations should be consistent. So should double returns or whatever space you've designated between paragraphs.

- Use a spell checker to make sure all typos have been caught.

➤➤ ## COPY LENGTH
Tips for Cutting Copy

- Pull out the padding in the copy. Phrases with overlapping meanings such as "just recently" or "each and everyone" are redundant.

- Try to reduce phrases to one or two words. For example, statements such as "in a timely manner" can be replaced with "promptly." Or "in accordance with" can be replaced with "by" or "under."

- Eliminate unnecessary words and phrases such as "it is interesting that" or "needless to say."

- Replace couplings of words such as "do not" and "is not" with their contractions, "don't" and "isn't."

PROOFREADING

Understand Proofreaders' Marks

Proofreaders and editors mark up manuscripts with symbols that are widely used and understood. Here are some of the marks most frequently used.

Commonly Used Proofreader's Marks

EXPLANATION	MARK	HOW USED
Delete or take out	*ℓ*	Tricks of the Trade*ℓ*
Let it stand	STET	Tricks of the ~~Trade~~ STET
Period	⊙	Tricks of the Trade⊙
Lower case	l.c.	TRICKS OF THE TRADE
Capitalize	≡	tricks of the trade
Italics	*ital.*	Tricks of the Trade
Bold Face	b.f.	Tricks of the Trade
Insert space	#	Tricks of the Trade
Close up	⌒	Tricks of the Trad e
Spell out	sp	Trcks of the Trde sp
Transpose	∼	Tricks the of Trade
Paragraph break	¶	Everything you need to know is in this book. Another option is a book called *Tricks & Techniques*.

These symbols are commonly used by proofreaders and editors when marking up manuscripts.

...ILLUSTRATORS

CHAPTER TWO

➤➤ Advice from illustrators and illustrators' reps on how to

find an illustrator who best suits the job at hand, what

to expect in terms of standard trade practices and how

to work together to get the best possible results.

MINI-INDEX

➤ ➤ ## ILLUSTRATION MEDIUM
A Tight Deadline May Dictate the Illustration Medium You Choose

When you're under a tight deadline, choose an illustrator who works with a medium that can be quickly digitized. Flat illustration mediums such as pen and ink, watercolor, gouache, pencil and airbrush can be scanned for four-color reproduction directly from the original art. Pastel and charcoal, three-dimensional illustration mediums such as collage, and oil paintings can add days to your time frame because they have to be photographed so that the resulting transparency can be scanned. Of course, digital illustrations don't require any scanning at all.

Illustrator Mike Quon's digital rendering technique allows him to expedite delivery of his work by e-mailing his concepts and final illustrations to clients.

➤ ➤ ## COLLABORATION
Let the Illustrators Do Their Job

When you go to the dentist to get a crown, you trust that dentist as a professional. You don't tell the dentist how to do her job. If you're working with recognized illustrators, you're hiring them to give you their vision. I think sometimes problems occur because the art buyer wants a big-name illustrator, but then they want to pigeonhole them into their own vision.

Allan Comport, artists' representative, Washington, D.C.

➤➤ COLLABORATION
Concept-Driven Artists Need the Freedom to Conceptualize

Committees of art directors and other corporate executives often make decisions about concepts and approaches that speak about their product or what it is they want to do. When they hire an illustrator to do the artwork, they manipulate and overdirect the artist to the point where the work becomes watered down and homogenized. The illustration will be well executed and have everything the client wants, but it won't capture the essence of what the illustrator does. Experienced illustrators take on this type of work because it pays well, but the best work that a seasoned illustrator who is a conceptualizer can produce involves the least amount of art direction. Conceptualizers feed off of a concept and it's part of the energy that drives their work.

David Beck, freelance illustrator, Cincinnati, Ohio

➤➤ ILLUSTRATION
Plan Ahead for Placement of Text and Images

When commissioning an illustration that will be part of a layout, plan your layout before contacting the illustrator. Why? Because the last thing you want is text on top of the primary subject of the illustration. It's important to let the illustrator know, before she begins, where text will overprint the illustration so that dead space or background can be incorporated into this area.

➤➤ COLLABORATION
Things to Discuss When Commissioning an Illustration

- What you have in mind for the illustration
- Its dimensions
- Black-and-white or color
- Deadline for concept sketches and final art
- Fee
- Who will pay for shipping

George Thompson, Thompson Studio, Doylestown, Pennsylvania

➤➤ ## COLLABORATION
Don't Make a Square Peg Fit Into a Round Hole

It's important for a designer to choose the right illustrator for the job. If you have a humorous piece, you want to pick a humorous illustrator. Sometimes a designer or art director will pick an illustrator out of a book and try to make them into what they need. It's like casting a movie—you want to cast the right person for the job. Ask for samples, look at the illustrator's portfolio. After awhile, you'll develop a pool of illustrators whose style you are familiar with.

George Thompson, Thompson Studio, Doylestown, Pennsylvania

➤➤ ## PRICING
Fees for Advertising vs. Editorial Illustration

Illustrators can demand a much higher price for work in advertising than they could hope to get from an editorial commission. In publishing, there is generally a range of set fees, with color work being more highly paid than black and white.

Excerpted with permission from *How to Find and Work With an Illustrator,* by Martin Colyer, published by North Light Books

➤➤ ## ILLUSTRATION
Remember Search Time When Considering Stock as an Illustration Option

Designers will often spend hours on the Web or browsing other sources looking for a stock illustration that is an exact fit to their needs. By the time they've paid the agency fee and factored in their own time involved in the search, they're likely to be paying more for the stock illustration than if they had commissioned the work from scratch.

Scott Hull, Scott Hull Associates, Dayton, Ohio

➤➤ ## ILLUSTRATION MEDIUM
Acceptable Turnaround Time

What's considered reasonable turnaround time for an illustration? It varies depending on the illustration medium and where the illustration will appear.

Editorial illustration, particularly for dailies or weeklies, typically involves extremely quick turnaround, sometimes twenty-four to forty-eight hours. Magazines grant a little more latitude, often a week to a week and a half. Books and advertising grant even more time, because there are typically more people involved in the approval process.

"It also depends on the style," says illustrator George Thompson. "Realistic illustration often involves using references and that requires extra time." Thompson points out that his humorous illustrative style involves less turnaround time because his need for visual references is minimal.

George Thompson, Thompson Studio, Doylestown, Pennsylvania

George Thompson's illustrations appear widely in magazines, books and advertising. The technique he used on this pen-and-ink and water-color illustration typically involves five to eight days turnaround time.

➤➤ PORTFOLIO
Portfolio Etiquette

- When asking for a portfolio, give the illustrator or illustrator's rep enough lead time to assemble a portfolio of samples that is customized to the parameters of the assignment.

- Handle samples with care so they'll be returned in good condition.

- If you can't offer an illustration assignment, include a note that lets the illustrator know the results of the portfolio review when returning materials.

- Return the portfolio within a week. If you need to keep it for a longer period of time, call the illustrator or illustrator's rep and explain why you need more time to review it.

- Offer to pay at least one way for the shipping of the portfolio, especially if you don't award an assignment to the illustrator or illustrator's rep.

Allan Comport, artists' representative, Washington, D.C.

➤➤ RESOURCES
Be Informed

Be aware of what's happening in the illustration world and how to use illustration to your advantage. Look at magazines that feature illustration as well as design and illustration annuals to see what the latest trends are and who's getting recognition.

George Thompson, Thompson Studio, Doylestown, Pennsylvania

➤➤ PRICING
Experience vs. Budget Limitations

There are a lot of illustrators out there, all bringing different levels of experience to the table. Unlike other creative disciplines, where it may take a few years of experience to develop proficiency, many illustrators come out of school already talented enough to deliver professional-quality work. Illustrators in this situation will be willing to work for less for the exposure they can get and are likely to offer their services at a bargain price. On the other hand, while experienced illustrators will command a higher price, they're more likely to give you tried-and-true results when they deliver. Savvy art directors may want to allocate their illustration budget in a way that allows them to commission seasoned illustrators to do illustration for where it counts the most—covers, full-page illustrations, ads, etc.—and hire less experienced illustrators for spot illustrations and assignments that allow for more creative experimentation.

➤➤ ILLUSTRATION
Know What You Want to Convey, Not What the Illustration Will Be

When contracting with an illustrator, you should be clear about what you want the illustration to say, not necessarily what you want the illustration to be. If you know that, you'll pick the right illustrator for the job and you won't be surprised with what they come up with.

George Thompson, Thompson Studio, Doylestown, Pennsylvania

➤➤ PRICING
Newcomers Offer Talent at Bargain Prices

If you're working on a limited budget, you may want to look for the "rising stars"— illustrators with little experience but a lot of talent.

George Thompson, Thompson Studio, Doylestown, Pennsylvania

➤➤ COLLABORATION
Don't Hamstring Your Illustrator

Sometimes I'm given a manuscript or article to read and have the freedom to come up with a suggestion for an illustration idea. Other times, I'm told exactly what I need to illustrate. As an experienced illustrator, I really appreciate and prefer being able to have some input on what the illustration will be. When somebody has a very specific idea about what they want, it's really difficult to read their mind and produce exactly what they're envisioning. Things work out much better if the illustrator is given some freedom and input on illustrating a concept that everyone is happy with.

Craig Boldman, freelance illustrator and writer, Fairfield, Ohio

➤➤ SIZE DIMENSIONS
Let the Illustrator Determine Proper Scale

Illustrators create an illustration based on how their work is best reproduced. Some techniques look better when they're printed at the same size, while others look better when scaled down. When you commission an illustration, give the illustrator the dimensions of the area that it will fill in final form.

060575-5405-80475

NUTS & BOLTS

➤➤ PRICING
Fee Standards for Commissioning an Advertising Illustration

Advertising illustration prices are negotiated strictly on a use basis, with extra pay added for the sale of residual or all rights, complexity of style or extra-tight deadlines. Advertisements usually are thought of in terms of multiple appearances. Therefore, a sale of usage rights in advertising may refer to limited or unlimited use in a specific area within a specified time period; for example, they may be "limited to one to five insertions in consumer magazines for one year." The media and time period for which advertising rights are being sold should be made clear and the price agreed upon before the project starts.

Excerpted with permission from the *Graphic Artists Guild Handbook: Pricing & Ethical Guidelines*, 11th edition, published by North Light Books

➤➤ ILLUSTRATION MEDIUM
Illustration vs. Photography

When is illustration preferable to photography? If realism or recognition value is important, photography is your best option. Movie ads consistently show photographs of the stars because their recognition level, as celebrities, is a factor in drawing people to the film. However, if you want to communicate a feeling, illustration may be the best way to go. Romance novels, for instance, have depicted model Fabio on their covers for years in illustrations, but never photography. That's because illustration is usually the more expressive of the two mediums.

George Thompson, Thompson Studio, Doylestown, Pennsylvania

➤➤ PRICING
Additional Usage Fees for Advertising Illustration

In addition to the original fee for an ad illustration, expect to pay the following fees (listed as percentages of the original fee) for original art and other applications of the illustration.

Separate sale of original artwork — 75 percent

Unlimited use within same media for one year — 50 percent

Unlimited use, any print media, no time or geographic limit — 100 percent

Total copyright transfer, not including original art — 200 percent

Adapted with permission from the *Graphic Artists Guild Handbook: Pricing & Ethical Guidelines*, 11th edition, published by North Light Books

➤➤ COPYRIGHT
When Do Old Illustrations Become Copyright Free?

Many designers wanting to use an illustration they've found in an old magazine, catalog or book don't fully understand whether or not they're violating copyright laws if they use it. Older artistic creations that are no longer protected by copyright fall into a category called public domain. Here are some guidelines to follow when determining whether or not an old illustration qualifies as art in the public domain:

- Uncredited illustrations and photographs found in printed materials seventy-five years or older can be used without copyright restrictions.

- For works created anonymously or under a pseudonym, protection lasts for one hundred years after the work is completed or seventy-five years after publication, whichever comes first.

- For credited illustrations, copyright protection for any work lasts for the life of the artist plus fifty years. For works created by two or more people, protection lasts for the life of the last survivor plus fifty years.

Adapted with permission from "Copyright Faqs," by Poppy Evans, *2000 Artist's & Graphic Designer's Market*, published by North Light Books

Old illustrations such as this one, from a book printed in 1898, are in the public domain and can be used without fear of copyright infringement.

➤➤ COPYRIGHT
Uncle Sam Gives Something Back

Any illustration you may find that's created by the U.S. government falls into the category of public domain, meaning it's free from copyright infringement. Manual diagrams, direct mail and ad illustrations all qualify.

➤➤ PRICING
Rejection Fees

Rejection is a difficult business. It is not simply a case of a bad piece of work going unpaid. If an illustrator has not achieved what you expected, you have to accept at least part of the responsibility for not having briefed the illustrator or supervised the work properly, and you must agree on a mutually acceptable settlement. Contracts sometimes specify a cancellation or rejection fee, usually 50 percent, but if there is nothing in writing, each case has to be treated separately. You should assess the reasons for the failure of the job and reach a figure in settlement.

If the illustrator has just started the job, the rejection fee may be less than it would be if the illustration were completed and the job fell through for reasons that have nothing to do with the illustrator. If an article is dropped from the magazine, for example, the art director has an obligation to honor the full fee.

Excerpted with permission from *How to Find and Work With an Illustrator*, by Martin Colyer, published by North Light Books

➤➤ PROOFING
Rembrandt Redux

If you commission an original illustration that incorporates type, make sure someone is responsible for proofreading the art. I once printed twenty-five thousand covers for Teleflora with an illustration that mimicked the style of an old film poster. Imagine my chagrin when a reader noted that the company's name had transformed itself into Telefora.

Adapted with permission from "Tech Tips," by Constance J. Sidles, *HOW* magazine, February 1996

➤➤ COLLABORATION
Don't Develop a Bad Reputation

Art directors and designers can develop a reputation among illustrators—who's good to work with versus who's not. Treat the people you're working with, with the same respect and consideration you would expect from others.

George Thompson, Thompson Studio, Doylestown, Pennsylvania

PRICING
Expect to Pay a Kill Fee if You Need to Cancel the Commission

If a job is canceled after the work is begun, through no fault of the artist, a cancellation or kill fee often is charged. Depending upon the state at which the job is terminated, the fee should cover all work done, including research time, sketches, billable expenses and compensation to the artist for lost opportunities resulting from refusing other offers to make time available for a specific commission.

Adapted with permission from the *Graphic Artists Guild Handbook: Pricing & Ethical Guidelines*, 11th edition, published by North Light Books

...PHOTOGRAPHERS

CHAPTER THREE

➤➤ How to work with photographers, produce professional-

quality photographs on your own and make the most of

photos that are less than perfect.

MINI-INDEX

PREPARATION

➤➤ ## COLLABORATION
Let Your Photographer Know What You Want Before You Begin

When working with a designer, I like to get as much information up front to make the whole process flow smoothly. For instance, what style of photography are they looking for? It often helps if they have samples of the style or technique they want. I also want to know how much art direction they will be doing. Some designers want to be very involved through the whole process, while others trust my vision and let me make pictures. One version isn't better than the other, provided everyone is happy with the end result.

Brad Smith, Photosmith, Cincinnati, Ohio

➤➤ ## TRANSPARENCIES
How to Evaluate Transparencies

Color transparencies generally give brighter, sharper results in four-color than color photos. When evaluating transparencies, follow these guidelines to determine what will give you the very best reproduction quality:

- **Make sure the transparency is an original. Duplicates are not as clear and never produce results that are as good as an original.**

- **Avoid grainy-looking or blurry transparencies. Some 35mm films have more grain than others, and although the grain may not be apparent to the naked eye, enlargements made from these transparencies will bring out the graininess in the film.**

- **Look for reasonable contrast. Transparencies with a color cast can generally be corrected when they are scanned and brought into a photo-editing program, but contrast problems are harder to correct.**

➤ ➤ MEDIUM
Advantages of Digital Capture Over Traditional Photography

- Photo shoots — Rather than waiting sixty seconds for a Polaroid to develop and hoping to get the same thing on film, it allows a client or art director to see exactly what the shot was when it was recorded and approve it.

- Comps — If you're unsure about whether or not a client will go for the concept and the expense involved in professionally shooting the images you want, a digital photo will give them the idea of how their product (or other image) will look in your design concept.

Gregory Wolfe, Gregory Wolfe Associates Inc., Blanchester, Ohio

➤ ➤ COLLABORATION
First-Timers Should Supervise Photo Shoot

If I have never worked with a designer before, I prefer that they be there for the photo shoot just to make sure the client is getting what they want. I try to make the process fun and enjoyable—it makes it seem a lot less like work if you like what you're doing.

Brad Smith, Photosmith, Cincinnati, Ohio

➤ ➤ MEDIUM
Color Print, Transparency or Digital Capture?

The type of image you provide the printer to start with has the greatest impact on what you'll get back. The variables in original photographs include color balance, exposure, grain, sharpness, detail, the size of both the original and the finished image and, based on the type of film emulsion used, the level of color saturation. Transparencies differ from prints in that a transparency has a greater tonal range, offering optimal color reproduction. However, because the tonal range in a color print is already compressed, it's easier to match on press. Images that are created digitally vary widely in the amount of detail or resolution they contain, depending on the memory and quality of the digital camera used.

Adapted with permission from The Warren Standard, Vol. 5, No. 1

NUTS & BOLTS

➤➤ SIZE DIMENSIONS
Weighty Photos

As everyone knows, the camera adds ten pounds. This "extra weight" is the result of reducing three dimensions to two. Much of the depth we perceive in the 3-D world is transmitted into width in a photo. You'll get more realistic results by slimming the figures in the final, printed version by using the computer to scale your photo to 90 percent of its width.

Adapted with permission from "Shortcuts," *Step-By-Step Graphics*, Vol. 15, No. 6, November/December 1999

➤➤ PHOTOGRAPHS
How to Get the Most From Photographic Prints

Transparencies and digital photography usually offer the best means of reproduction. However, if you're given color photographs, here's how to make the best of what you've got:

- If possible, select a photograph that's in good focus.

- Photographs made on smooth, matte paper give the best reproduction. Glossy prints tend to cause problems when scanned.

- Scale the print as close to 100 percent of its original size as possible.

- If you're scanning the photos yourself, check to be sure your scanner has its Unsharp Masking feature turned on to heighten detail and contrast.

➤➤ STOCK PHOTOGRAPHY
Cheap Sources for Stock Images

Alternative sources to stock agencies such as universities, corporations, museums and tourism bureaus may offer the photographs you want at a better price, but may take longer to deliver. If you find a free source, it may take weeks or months to get the images because of others also in line for the material.

Adapted with permission from "Navigating the Stock Maze," by Hal Stucker, *HOW* magazine, June 2000

➤➤ STOCK PHOTOGRAPHY
Unusual Sources for Stock Images

You may have an easier time finding what you need and save money if you bypass stock agencies and check into other sources for the photographs you need.

Looking for:	Look here:
Business	Chambers of commerce, corporations
Disasters	Disaster-relief agencies (i.e., Red Cross)
Education	Universities
Government	Government agencies and departments
Historical	Auction houses, historical societies, museums, state libraries, universities, newspapers, national archives
Military	Military offices
Recent events	Newspapers
Regional	Chambers of commerce, international tourism offices, state libraries, travel and tourism bureaus
Research	Universities, research institutes, science museums
Transportation	Transportation companies (e.g., Amtrak)
Travel	International tourism offices, travel and tourism bureaus
Wildlife	Aquariums, zoos

Excerpted with permission from "Navigating the Stock Maze,"
by Hal Stucker, *HOW* magazine, June 2000

➤➤ STOCK PHOTOGRAPHY
Save Set-Up Shot Charges—Purchase Outtakes as Stock

When working with a particular subject matter, you may be able to purchase outtakes from a photographer who has done work for a client on a regular basis that specializes in that subject. If you need musical subject matter, for instance, find out who photographs your local symphony and see if you can purchase stock usage rights for images the symphony hasn't used. Most photographers are happy to make money by selling usage rights to these unused images.

ADOBE PHOTOSHOP SHORTCUTS
Fall Colors Achieved in an Instant

What do you do when you're doing a photo shoot for a fall catalog and it's the middle of spring? Change the color of the leaves in Photoshop. Use the Magic Wand tool to select the area to be changed, and adjust Hue and Saturation until the desired color is achieved.

Pamela Monfort, Bronze Photography, Cincinnati, Ohio

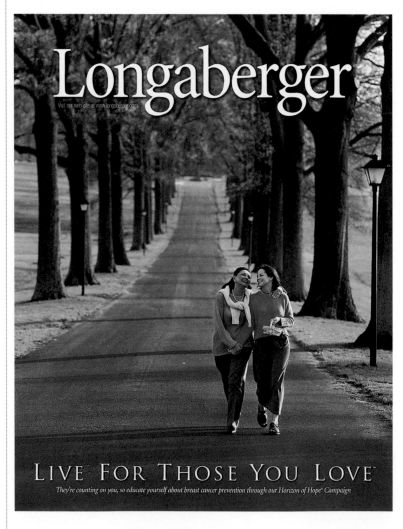

The photograph on this catalog cover was taken in the spring when the leaves were green. Retouching in Photoshop gave the leaves their fall glow.

SCANNING
Scan Prints Without Moiré

When scanning an image that has already been printed, you may see a moiré pattern from the halftone dots in the image. If your scanner doesn't have a de-screen option, experiment to find a resolution that minimizes the moiré. Often, a resolution equal to or double the printed line screen will work. Once you get a fairly good scan, use Photoshop's Gaussian blur filter (at a setting of less than one pixel) to slightly blur the moiré until it's not visible, and then apply an Unsharp Mask to sharpen the image. You may also improve the scan by rotating the image slightly, which changes the halftone screen angles. Rotating 45 degrees works well for black-and-white images, but with CMYK images, you'll need to experiment. - David Claunch

Excerpted with permission from "101 Hot Tips," *Publish* magazine, September 1998

PHOTOGRAPHS
Tips for Photographing Metal

Metal is extremely difficult to photograph because its metallic surface is likely to reflect the photographer or other items that your viewer may recognize. The best way to deal with this problem is to try and eliminate all recognizable reflections during the photo shoot.

To make the most of the metal's reflective qualities, when the photo is scanned, ask your color separator to concentrate on the highlights in the photo. That way, the highlights will carry no halftone dots and the midtones will carry the widest possible tonal range.

ADOBE PHOTOSHOP SHORTCUTS
Use Blur to Remove Specks and Scratches

To get rid of dust specks and scratches quickly in Photoshop, use the Blur tool at 100 percent pressure. Set the Blend mode to Darken to remove light specks and Lighten to remove dark spots or blemishes. - Katrin Eismann

Excerpted with permission from "101 Hot Tips," *Publish* magazine, September 1998

080675-5405-80475

➤➤ TRANSPARENCIES

How to Judge Exposure on a Color Photo or Transparency

These three photos show the differences in detail and color between an overexposed (left) and an underexposed (right) photo and a good reproduction (bottom).

Poor color saturation and lack of detail characterize the over-exposed photo.

In the underexposed photo, the detail is better and color saturation is better, but there is a loss of detail in the shadow areas and a color bias toward blue—a common problem with underexposed photos. To solve this, make sure more yellow is added when the photo is separated.

Best reproduction is achieved when color is in balance and details can be seen in the shadows as well as the highlight areas of the image.

➤➤ SCANNING
Scan Emulsion Side Down

When scanning 35mm slides or other transparencies, make sure they're scanned emulsion side down. (The emulsion side is usually the duller one.)

➤➤ TONE COMPRESSION
Understanding Tone Compression and How It Affects Photographs

Outdoors, on a sunny day, the ratio (or difference) between the lightest tone we can see and the darkest can be as high as 1,000 to 1. Between the lightest part of a cloud and the darkest area of black, for example, there may be a range of 1,000 to 1.

Film and photographic paper reduce this ratio to 100 to 1 and usually much less. Halftone screening, separating and printing reduce it still further—to a maximum of 20 to 1.

This reduction is called process tone compression. The number of tones that remain in the final reproduction of an image creates tonal range. Of the factors that determine tonal range, two are critically important. The first is the difference between the brightness of the unprinted paper and the maximum ink density. These become the two ends of the range, since no highlight can be brighter than the paper on which it's printed, and no shadow can be denser than a solid black.

Although compression is a factor in the reproduction of photographs, its effects can be minimized. When using duotones, tritones and quadratones, which produce extremely deep shadows with multiple impressions of ink, you can increase the midtone details within the tonal range. The same principle applies to four-color process work.

The second factor is screen ruling. The finer the line screen, the more dots an image contains and therefore the greater the number of tones you can create.

Condensed with permission from *The Warren Standard*, Vol. 5, No. 1

➤➤ SIZE DIMENSIONS
The Quality of Your Photo Should Dictate Its Dimensions

- Don't let your layout dictate the dimensions of your photos. The quality of the photo should determine its size. Great photographs with aesthetic and/or emotional appeal deserve first-class treatment. Make the most of them by running them as large as possible.

- Don't decide what the dimensions of a photo should be and then crop to fit. Instead, crop the best part of the photo and base your photo's final dimensions on this area.

- Grainy or out-of-focus photos should be reduced and never enlarged.

➤➤ ADOBE PHOTOSHOP SHORTCUTS
Color Balance With a Gray Card

Whether you shoot pictures with a film or a digital camera, you'll eventually run into trouble color balancing your images. You can greatly simplify the process of color-correcting your images if you start your photo shoot with a test shot containing a photographic gray-card target as a reference. Have your subject hold up a Kodak gray test card (sometimes called a Zone 5 card), or prop the card up in the scene if you're shooting inanimate objects. Shoot the photo normally. Then, using the same lighting and camera settings, shoot the photo without the card.

In Photoshop, open the image containing the gray text card. Open the Levels dialog box by choosing Image, Adjust, Levels. The three eye-droppers (from left to right) adjust the black, gray and white balances, respectively. Choose the middle dropper and click the gray card in the image. That should come very close to balancing the image. Save the adjustment as Gray Target Adjustment. Now open the image photographed without the gray card, open the Levels dialog box again and load your Gray Target Adjustment settings. Click OK to apply the adjustment to the new image. - Sean Wagstaff

Excerpted with permission from "101 Hot Tips," *Publish* magazine, September 1999

➤➤ SIZE DIMENSIONS
Keep Models in Shape

When you are photographing a live model, always set your camera at waist-height rather than at eye-height. Shot from eye-height, the top of the person's body appears to be larger than the bottom. Waist-level better maintains the body's proportions.

Excerpted with permission from "Shortcuts," *Step-By-Step Graphics*, Vol. 10, No. 5, September/October 1994

➤➤ ADOBE PHOTOSHOP SHORTCUTS
How to Make a Crooked Image Walk a Straight Path

Photoshop provides an easy method for straightening a crooked scan or cockeyed digital photograph. Select the Measure tool and draw a line along the edge of an element in the photo that should be exactly horizontal or vertical. Go to the Image menu and choose Arbitrary from the Rotate Canvas submenu. The angle that the image needs to be rotated automatically appears in the Angle box. All you have to do is click OK to straighten the image; then crop as desired. - Deke McClelland

Excerpted with permission from "101 Hot Tips," *Publish* magazine, September 1999

PHOTOGRAPHS
Prevent Reflective Glare With a Polarizing Filter

A good way to handle outdoor light is with a polarizing filter that will eliminate reflections from glass and all but metallic surfaces. This filter also strengthens many tones and improves the separation potential of a photograph or transparency.

Before a polarization filter was applied.

After a polarization filter was applied. Photosmith

• • • • • •

➤➤ ADOBE PHOTOSHOP SHORTCUTS
Make a Dust & Scratches Brush

There are two problems with running Photoshop's Dust & Scratches filter on an entire photo to get rid of imperfections: First, the degree of blurring needed to fix the worst spots may be more than you need to fix others, and the image may wind up looking blurred overall. Second, it can "fix" things that aren't broken, like removing the highlights in someone's eyes in a portrait. The history palette in Photoshop offers a way to fix problem spots.

Start the usual way by choosing Filter, Noise, Dust & Scratches. Apply the radius and threshold settings that fix most of the problem areas over the entire image, but don't worry about the worst ones. Now create a merged snapshot of the image in this slightly blurred condition: Option/click (Alt/click in Windows) the Create New Snapshot button on the History palette, and choose Merged Layers in the New Snapshot dialog box. Name the snapshot D&S Light. Then choose Edit, Undo and reapply it at a higher setting that gets rid of all of the dust and scratches in the image, including the worst ones. Take another merged snapshot, naming this one D&S Heavy. Once again, undo the filter.

Now you have a photo in its original state and two snapshots with different degrees of "fixing." Create a new, empty layer above your image and then choose the History Brush tool from the toolbox. In the History palette click to choose the D&S Light snapshot as the source for the History Brush and "paint over" the easier problems using the smallest, softest brush tip possible to do the job. Use the D&S Heavy snapshot to paint over the worst spots. - Linnea Dayton and Jack Davis

Excerpted with permission from "101 Hot Tips," *Publish* magazine, September 1999

➤➤ PHOTOGRAPHS
Setting Up Effective Group Shots

- Try to group subjects where there is very little background distraction. Never group in front of a window or against a wall with an assortment of pictures or other hangings.

- Action shots are always more interesting than static ones. Try to engage the group in an activity if the situation warrants it. Have them wave if they are departing for a trip, or stage a traditional "handshake" pose between two subjects.

- Never group your subjects so they are standing side by side in a line. Groupings like this accentuate height differences and can give the impression of a group of thugs in a police lineup.

- For visual variety, try grouping subjects informally, around a desk or another piece of furniture, with some seated and others standing behind.

- If possible, shoot your subjects from a higher or lower vantage point for the visual interest that an unusual angle provides.

➤ ➤ DIGITAL PHOTOGRAPHY

Pointers for Successful Digital Captures

- Ask the photographer to describe how her camera works and detail the size of the capture files. While it's true that captures can be blown up larger than scans from film, the acceptability of such an enlargement depends a lot on how far the printed piece is from the person viewing it. If they're standing a few feet away, small artifacts or pixelations won't be any more noticeable than film grain would be at the same distance. If they're holding the piece in their hands, though, even the tiniest defect will be clearly visible, so you'll really want the capture to be as large as your final reproduction size.

- When possible, provide the digital photographer with the name and phone number of the prepress or print shop outputting the separations so they can discuss the ideal CMYK conversion. If you don't have that information, at least tell the photographer whether the paper will be coated, uncoated or newsprint and if the paper will be clean or off-white; she can then set appropriate dot gain and color for the files.

- Ask the digital photographer to provide hi-res and low-res files of each capture. If both file versions have the same name, you can use the low-res file during the design phase and the printer can easily substitute the hi-res files before going to film or plate.

- Request oversized files from your photographer so that you can later re-purpose the images. Be sure to use Photoshop to resize the captures before dropping them into your layout. Not only can layout programs such as QuarkXPress cause "jaggies" when reducing file size, but using these programs for that purpose dramatically increases the RIP time.

Excerpted with permission from "Smile, You're on Digital Camera," by Judy Herrmann, *HOW* magazine, August 1999

➤➤ SCANNING

Photograph Small Objects With Your Scanner

The scanner is really a digital camera. It may not be portable, but it functions the same way. In fact, it often does a better job of photographing small and flat objects than a set-up shot. Coins, jewelry, pencils, candy, marbles are all good candidates for a direct scan. Arrange them on your scanning bed, back with a sheet of white paper and, voilá—a photo in an instant.

How Sweet It Is ! It's Jessa Wedeen's Sweet Sixteen and it would be a real treat if you would help her commemorate this momentous occasion by joining her for a dinner celebration on Friday, August 22, 1997, 7:00 pm

Faced with producing a "Sweet Sixteen" birthday party invitation for his daughter, designer Steve Wedeen of Vaughn Wedeen Creative, Inc., placed items from the studio's candy machine (and a packet of sugar from the studio's coffee station) on the scanner to produce an instant poster invitation.

➤➤ TONE COMPRESSION

Squeeze Play

It's a fact of printing life that the tonal range of a press can't match the tonal range of film. The best that printers can achieve is a range corresponding to approximately four F-stops. So when you're photographing contrasting subjects, like metallic objects on deeply shadowed backgrounds, take light-meter readings of key details as well as an overall reading. To preserve shadow or highlight detail, use lighting to compress the tonal range before you get on press.

Excerpted with permission from "Tech Tips," by Constance J. Sidles, *HOW* magazine, February 1996

➤➤ SCANNING
Get the Best Range From Your Color Scans

Many flatbed scanners support 30- or 36-bit color scanning, which captures a larger number of shades per color than older, 24-bit scanners (which capture 256 levels each of red, green and blue). When the raw scan is loaded into Photoshop, you'll need to convert it to a 24-bit RGB before you can retouch it or convert it to CMYK, but first use the Levels tool to set your highlight, shadow and midtone points to capture the best range of colors in the image. - David Claunch

Excerpted with permission from "101 Hot Tips," *Publish* magazine, September 1998

➤➤ DIGITAL PHOTOGRAPHY
Digital Capture: You Get What You Pay For

Having shot digital studio shots as well as on location, I don't know why I would ever go back to film. The big advantage is turnaround time, with everything else being pretty equal. You can literally photograph anything digitally, but all digital cameras aren't alike. There's such a range of what people will think a digital camera will do. A $1,400 camera has the same specs as one that costs $8,000 or $25,000, but the difference in their image quality is substantial. You should be working with 8- and 16-bit files that are 17–35MB in size—that's 3056 × 2032 pixels. With our camera, I can take an image and enlarge it 500 percent and still have a high-quality digital image for packaging—even larger for posters and point-of-purchase displays. You could take a similar picture with another camera and you wouldn't be able to enlarge it to 200 percent in a commercial application.

Gregory Wolfe, Gregory Wolfe Associates Inc., Blanchester, Ohio

• • • • • •

➤➤ ADOBE PHOTOSHOP SHORTCUTS
Quick Photo Adjustments

You can use Photoshop's Emboss filter to pump up depth in a photo. First, copy the photo layer and emboss the copy, making sure the angle of the embossing follows the lighting in the photograph. Then set the embossed layer to Hard Light or Overlay mode and, finally, adjust the opacity a bit if you want to soften the effect.

Excerpted with permission from "Shortcuts," *Step-By-Step Graphics,* March/April 1999

➤➤ CONTACT PROOFS
Save Printing Charges

Don't overlook scanning contact proofs as a means of creating an interesting photographic treatment. You'll bypass the cost of making photographic prints, and the filmstrip edges can add graphic interest to your layout.

Faced with a series of pedestrian images of a printing facility that would have been dull if reproduced on a larger scale, the designers at Platinum Design chose to feature them exactly as they were on the photographer's contact sheet. The treatment adds a sense of immediacy to the images that reinforces the brochure's message of deadline-oriented quality service.

ADOBE PHOTOSHOP SHORTCUTS
Fudge the Details

If your photo's slightly out of focus and detail isn't important, posterize your photo in a photo-editing program.

Converting the posterization to a duotone enhances its emotional value and visual appeal.

An eight-level posterization turns the photo into a graphically reduced image. Its lack of clarity becomes acceptable because the image is perceived as a rendering rather than a photograph.

The fuzzy quality of this black-and-white photo makes it unusable as is.

DIGITAL PHOTOGRAPHY

Digital Capture: A Low-Cost Alternative for Still Photography

You can get high-quality prints, 35mm slides and high-res digital files of still shots without spending an arm and a leg. Have your work photographed by a studio that offers professional quality digital capture. It's easy to retouch the digital images to remove unwanted elements such as cords, etc. The digital files are easily separated into CMYK films for any kind of printing application and can also serve as low-res JPEGs for a Web site. You can also have Fujix 3000 Pictography continuous-tone prints made of your retouched images and take the prints to a local film lab for inexpensive 35mm copy slides. You get multiple uses without the high cost of 4 × 5-inch (10.16cm × 12.70cm) transparencies and drum scanning.

Nina Courtney, Nina Courtney Photographics, Sacramento, California

The original digital capture of this series of light sculptures included their electrical cords.

The digital images were easily retouched in Adobe Photoshop where the electrical cords were removed with the Rubber Stamp tool.

ADOBE PHOTOSHOP SHORTCUTS
Eliminate Background Problems

If your subject looks fine, but the background detracts from your subject or is otherwise less than perfect, run your photo as an outline. Take out the background by creating a mask in a photo-editing program.

PHOTOGRAPHS
Achieving Richness in Black-and-White Images

The computer "sees" 256 levels of gray in a gray-scale image, but presses allow for only thirty to seventy levels per ink. If it's important to get a broad range of grays, consider adding a gray ink and running the image as a duotone or tritone, or try a technique called double-dot where two plates that print black are used. With double-dot, the plate is exposed with special emphasis on highlight detail. The second plate emphasizes the shadows and is angled at 75 degrees.

ADOBE PHOTOSHOP SHORTCUTS
Isolate Channels to Remove Noise From Photos

To remove film grain from a scanned photograph, people usually invoke Photoshop's Despeckle noise filter. The result is softening of the overall image, which helps reduce graininess but can also cause you to lose small details, such as words on a sign in the background or eyelashes on a face. To get better results, consider the information contained in each RGB channel of an image: the red channel contains the contrast information; the green channel contains the detail information; and the blue channel contains the noise, including film grain and other undesirable artifacts. Apply the Despeckle filter to the blue channel only, and you'll reduce the grain without blurring the whole image. - Bert Monroy

Excerpted with permission from "101 Hot Tips," *Publish* magazine, September 1999

FINISHING TOUCHES

➤➤ **PHOTOGRAPHS**

Be Sure Photos Are in Focus

When checking photographs, you'll want to be sure they're in proper focus. Check these things with a magnification loupe:

- Details in small, round areas such as eyes or buttons.
- Straight line areas such as hair and grass.

➤➤ **PREPARATION**

Label Those Images

To safeguard against loss, label all photographs and transparencies with your studio's name and phone number before you send them to your printer or service bureau.

➤➤ **PHOTOGRAPHS**

Dramatic Black-and-White Photos

When printing black-and-white photographs on coated stock, you can achieve extra-dark, rich blacks by having a duotone made. Have your printer print the duotones in process black and Pantone black inks.

➤➤ **PREPARATION**

Organize Your Photos for Your Printer or Service Bureau

Magazines and other high-quality publications requiring professional scans need a coding system to indicate where photos go on each page. Label each photo or transparency with its page number and assign a letter code to each (for instance, 40-A, 40-B, 40-C for photos and transparencies that appear on page 40). Include a marked-up laser print of each page with FPO scans of each photo in place, and label each of these images with its corresponding code. Using a system like this will relieve your vendor of the chore of trying to match images with pages and ensure that your photographs and transparencies will appear where you want them to be.

SCANNING
Studio or Professional Scanner?

Designers are often disappointed with the poor quality they get when the photographs they've scanned on their studio's flatbed scanner are finally printed. Others don't realize that they may not need to spend money on professional scans when a studio scanner will do. Here are some rules of thumb to consider when determining which option to choose:

- Black-and-white or color — If achieving accurate color is important, a professional scan is more likely to yield dependable results.

- Size — Small-scale photographs such as mug shots are less likely to reveal the fuzzy details that can occur with studio scans.

- Paper — Because of its porous surface, uncoated paper will tend to slightly blur printed photographs. The details of a high-quality scan may be lost when this happens. On the other hand, a premium coated paper will reveal any loss of detail in a low-quality scan.

PAPER
...MERCHANTS

CHAPTER FOUR

➤ ➤ Technical advice from paper manufacturers and

distributors on how to select the right paper for the

job and work most effectively with paper and paper

products and paper suppliers.

►► MINI-INDEX

PREPARATION

➤➤ COMPOSITES
Have Your Paper Merchants Make a Comp

Most paper merchants will prepare composites of their papers, trimmed and folded into folders or bound into brochures to your size specifications so you can determine how a piece will weigh and feel before you purchase the paper for it.

➤➤ PRICING
Tight Budget, Tight Deadline? Spec a House Sheet

If you're designing on a limited budget or a tight deadline, you'll want to come up with a design concept that will allow you to specify your printer's house sheet. House sheets are papers your printer stores on premises that are usually bought in bulk and offered at a discount to clients. They're typically papers that are commonly used such as white, coated stock in medium grades or a linen-finish, uncoated stock frequently used for stationery applications, but what's available will depend on the printer you use.

➤➤ ENVELOPES
Standard Envelope Types and Their Sizes

Not sure what an A2 envelope is? It might help to know that an A2 is an announcement envelope, usually made to match text and cover stock. Baronial envelopes are also used for invitations and announcements as well as greeting cards. Commercial envelopes, on the other hand, were specifically designed for correspondence. These envelopes are narrower and come in a wide range of sizes to accommodate letters and other business correspondence needs. Booklet style envelopes are large enough to contain media kits, annual reports and other large pieces. They're frequently made to match writing, text and cover weight stock. Catalog envelopes also accommodate the mailing of large pieces but are generally made from less expensive stock than booklet envelopes. They're used more for magazines and catalogs. Policy envelopes are used for bonds, mortgages and legal papers.

The illustrations on the following page show a few of the more common envelope types, along with their dimensions.

A2 (4⅜" x 5¾")

A6 (4¾" x 6½")

Although all envelope styles were originally designed with a specific purpose in mind, savvy designers may not want to limit themselves to the usage applications implied by each category. For instance, a No. 10 policy envelope (not shown) is the same size as a No. 10 commercial envelope but opens on the short end. Why not select the more unusual envelope style for a letterhead design, if it matches the other components in an identity system?

6¾ (3⅝" x 6½")

Monarch (3⅞" x 7½")

No. 10 (4⅛" x 9½")

• • • • • •

➤➤ PRICING
Minimize Paper Costs

To minimize paper costs, ask your printer for folding dummies incorporating the most economical press layouts possible. Then design your piece without any excess trim and with the largest number of pages per signature. Designing without a press in mind may be artistically valid, but it's also likely to boost spoilage and costs.

Excerpted with permission from "Tech Tips," by Constance J. Sidles, *HOW* magazine, February 1996

➤➤ SPECIALTY PAPERS
Tree-Free Papers Require Special Order Considerations

Don't expect your printer to stock or order specialty, non-wood pulp papers such as those made from kenaf, hemp and other tree-free fibers. You'll need to buy these papers yourself, meaning that you'll be responsible for payment as well as the quality, quantity and delivery time of the paper.

➤➤ PAPER SELECTION
Take Flocking Variances Into Consideration

Flocking can be an issue where small text is involved, particularly if the specks in the sheet are so large they interfere with legibility. You may choose a flocked sheet from a swatch book for a letter-head concept, and although the swatch book may show a sample with a minimal amount of flocking, the supply your printer receives can have a much greater proliferation of specks than you may have anticipated. Large specks in a stock can compete with the delicate design of a letterhead and interfere with legibility when photocopies or faxes are made from it.

➤➤ PAPER SELECTION
Colored Stock Makes a One-Color Job Colorful

When given a one-color budget, you can add color by changing the color of your paper. This can work for brochures, identity systems and other jobs that are comprised of several components.

Werner Design Werks' solution to a low-budget assignment for a promotional brochure was to combine various colored stocks for a one-color print run, as shown on the following page.

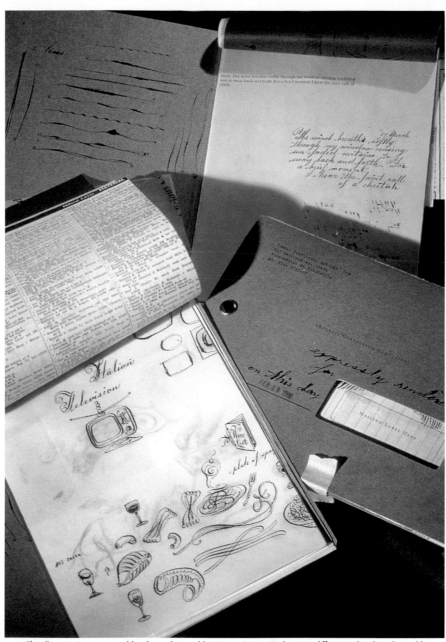

This illustrator's promotional brochure, designed by Werner Design Werks, uses different colored stock to add color to an all-black press run.

PAPER SELECTION
Appetizing Reproduction

Uncoated stock lends appealing texture to many projects, but it can be a disastrous choice for food photography, warns catalog consultant Elsperth Martin. Reds and browns tend to take on a purple cast, giving chocolate and red meat a decidedly unappetizing look, and all food photos look dull and stale on uncoated. Martin also recommends a matte finish, coated paper. "It makes food look more real than paper with a high gloss," she says.

Excerpted with permission from "Shortcuts," *Step-By-Step Graphics*, Vol. 16, No. 1, January/February 2000

PAPER SELECTION
How White Is White Paper?

White papers may look white to the naked eye, but some white papers have more blue dye in them than others. Those that have a blue-white coloration are often best suited for reproducing images of cars, produce, landscapes and other images that are enhanced by the crispness of a blue-white background. On the other hand, cosmetics, lifestyle images, greeting cards and other topics meant to convey a warm, familial quality can benefit from white paper that has a warmer cast.

PAPER SELECTION
Paper Smarts 101

Focus on selecting the most appropriate paper for your project. Consider a piece's functionality and your design before you begin to look at paper possibilities. Here are some guidelines to follow:

- Text-heavy projects require a paper with low glare. Uncoated paper is less likely to produce glare than a coated sheet.
- Four-color images that require good color reproduction need a bright, white paper with good holdout properties.
- Coated papers will reproduce images in greater detail. This can be advantageous if you have a crisp, high-quality image.
- Uncoated papers tend to fuzz details. This can work to your advantage if your images are less than perfect.
- If your piece will be folded or stapled, be sure the paper you choose won't crack or tear when folded.
- If you're dealing with a publication, coated papers tend to weigh more than uncoated papers, meaning that they can add to the weight of a mailing.

- Although they're lighter in weight than coated papers, uncoated papers will add bulk to your publication. This can work to your advantage if you want to give the impression of substantial volume but could be disadvantageous if bulk is a consideration for the binding method you're using.

- Be sure the varnish or laminates you're considering are compatible with your paper.

➤ ➤ SPECIALTY PAPERS
Custom Paper Adds a Custom Touch

For long-term or special projects, consider working with a paper mill to develop a custom paper for your client. When Buena Vista College celebrated its centennial, we worked with James River Paper to create a paper expressly for Buena Vista College and used the stock for letterhead, mailers, brochures, recruitment pieces, posters and other materials. We found that the quantity we needed for Buena Vista was well within the minimums required by James River. Due to the large volume of paper the college required, the cost was no more than what they would have paid for a stock mill item. In fact, the college was able to economize by ordering enough paper for all departments to use through an entire year and beyond.

Be sure to check with your paper merchant or directly with the mill about minimum requirements and lead times for custom paper.

John Sayles, Sayles Graphic Design, Des Moines, Iowa

Sayles Graphic Design's identity materials for Buena Vista College are printed on a custom paper. The gold paper with its red, blue and purple flocking reinforces the college's identity through its use of the college's signature colors.

➤➤ COLLABORATION
Avoid Paper Mistakes and Delayed Jobs

Get your printer involved early in the project planning. Show a comp and discuss paper possibilities at the onset of a job. A knowledgeable printer can suggest paper alternatives or changes in your design if your choice of paper is unrealistic for the type of project you're planning. It will also allow your printer to check on local availability of your paper. If a tight deadline is involved, ordering paper directly from the mill can add three to four days to a printing schedule.

➤➤ PAPER SELECTION
Take Weight Factors Into Consideration When Planning a Piece

The weight of the paper you spec can be a huge factor in the success of the piece you design. Here are considerations to keep in mind:

- A publication printed on coated paper will weigh more than its same-sized counterpart printed on uncoated paper. This can become a factor when designing manuals, where ease of handling is important or in a situation where mailing costs are a factor. Conversely, although it will weigh less, the same publications printed on uncoated paper will be thicker because uncoated paper is bulkier.

- The stock used for a printed piece, its envelope and any inserts needs to be taken into consideration when mailing costs are an issue. First-class mail weighing an ounce or less costs thirty-four cents per piece to send, but as soon as you go over an ounce, the price is fifty-five cents. The basis weights of all the papers that are used, whether they are coated or uncoated, will affect the weight of the piece.

- If mailing costs are a factor, make up a comp of your piece using the papers you're considering and weigh them on a postage meter.

➤➤ PAPER SELECTION
Paper Grain and Business Cards

Your paper's grain direction can affect the feel of a business card. Business cards printed on cover stock can feel flimsy if the cards are run with the longest dimension parallel to the "grain long" direction of the sheet. When printing business cards, make sure that the longest dimension of the card is printed against the grain of the sheet.

Trish Wales, Sappi Fine Papers North America, Landover, Maryland

GRAIN
Determining the Grain Direction of a Paper

Most designers know that heavy text and cover stock needs to be scored before it's folded, but designers often don't realize that paper needs to be scored "grain long" or with the grain of the paper. Folding against the grain, even with a score, will result in problems. Because of this, it's important to determine the direction of the grain in the paper before the piece is printed. To determine the grain direction of your sheet, fold it vertically and then horizontally. The fold line will be much more even when it's folded with the grain than when it's folded against the grain.

➤➤ PAPER SELECTION
Achieving a High Degree of Detail Requires Coated Paper

When it comes to detailed images, trying to print jobs traditionally reserved for a coated stock on uncoated papers can often yield disappointing results. Even after compensating for anticipated dot gain on film, uncoated paper will yield a loss of detail when working with delicate images and the finer screens they require (175 lpi or 200 lpi).

Trish Wales, Sappi Fine Papers North America, Landover, Maryland

➤➤ SPECIALTY PAPERS
Ordering Specialty Papers

Most specialty and eco-friendly papers (kenaf, hemp, cotton, etc.) are available in cut-sheet sizes only, often restricted to 8½ × 11 inches (21.59cm × 27.94cm). But if your order is large enough, some mills will customize for you, making either larger sheets or rolls. Check into this possibility if you're dealing with publications or a large quantity of identity materials.

➤➤ PAPER SELECTION
Be Flexible With Your Paper Specifications

The local availability of the paper you've specced can often have an impact on the completion date of your printed piece. If local distributors don't carry the stock you want, it may take a week or two before your printer can receive your paper directly from the mill. Be flexible about changing your original paper choice or adjusting the deadline for the piece if your printer is in this situation.

➤➤ PRICING
Don't Waste Paper

To avoid wasted trim and wasted money, design printed pieces with standard paper sizes in mind. All sheet sizes are based on 8½ × 11-inch (21.59cm × 27.94cm) increments; for instance, a 23 × 29-inch (58.42cm × 73.66cm) sheet yields eight 8½ × 11-inch (21.59cm × 27.94cm) pages. To check the sheet sizes in the paper you're considering for a project, check the swatchbook. Base the size of your piece on how many will fit (with bleed, if necessary) on a sheet with a minimum of wasted trim.

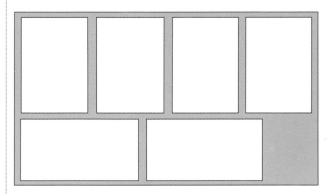

Here are some examples of how a printed project can be impositioned to fit on a 23 × 35-inch (58.42cm × 88.90cm) sheet of paper with a minimum of wasted trim.

Four 8-panel 4 × 9-inch (10.16cm × 22.86cm) brochures printed four up.

Six 8½ × 14-inch (21.59cm × 35.56cm) newsletters printed six up.

Nine 4½ × 6¼-inch (11.43cm × 15.88cm) greeting cards printed nine up.

➤➤ SPECIALTY PAPERS
Specify a House Sheet for Small Jobs

Printers need to buy an entire carton of paper and charge you for it when you specify a mill stock. This isn't cost effective when a small job is being run, such as printing a thousand 8½ × 11-inch (21.59cm × 27.94cm) sheets. Instead, specify paper that your printer already has on hand.

Karen Vatter, MPI, Cincinnati, Ohio

➤➤ POSTAL STANDARDS
Consider Basis Weight When Designing Business Reply Cards

Designers will frequently design a mailer with a tear-off reply card but fail to take into consideration the weight of the card when speccing the paper for the mailer. Letter mail needs to be a thickness of at least 7 points. In many cases, this translates to a 75-lb. cover stock for a postcard measuring 3½ × 5 inches (8.89cm × 12.70cm) to 4½ × 6 inches (11.43cm × 15.24cm). There are some 65-lb. cover stocks that meet this criterion, but you could never print a business reply card on a text weight paper and expect it to come back in the mail. Become familiar with automated postal standards before designing a business reply card.

➤➤ PRICING
Save Money by Speccing a Lighter Weight Paper

You can save money on a print job by reducing the basis weight of the paper involved. Here's an example of what you can expect to save when going with a lighter versus a heavier weight of the same text stock:

> 60 lb. costs 20 percent more than 50 lb.
>
> 70 lb. costs 15 percent more than 60 lb.
>
> 80 lb. costs 12 percent more than 70 lb.
>
> 100 lb. costs 20 percent more than 80 lb.

Excerpted with permission from *Getting It Printed*, by Mark Beach and Eric Kenly, published by North Light Books

➤➤ PAPER SELECTION
Supercalendared Considerations

In spite of its high-gloss finish, supercalendared stock is more porous than other coated stocks and yields a higher degree of dot gain, meaning that four-color inks, if printed too densely, will yield muddy colors on press.

To prevent this, be sure that the sum of percentages of the cyan, yellow, magenta and black in your colors never exceeds 260 percent.

➤ ➤ INK COVERAGE
Fiber Formulation Can Affect Ink Coverage

A paper's ability to accept ink is largely a factor of its finish and coating, but the paper's fiber formulation can also affect ink coverage. Poor formulation can cause ink to lay unevenly and appear shiny in some spots and dull in others. This can be a desirable effect in some cases, causing metallic inks to look like galvanized steel, for instance. However, it may not be desirable if you want flat, even coverage or if an uneven surface will affect the appearance of an image you're printing. If smooth coverage and image reproduction are a consideration, check a paper's fiber formulation by holding it up to a light. If the fibers appear to be mottled in areas, it's likely that your ink will appear mottled as well.

➤➤ COLLABORATION
Don't Forget Your Local Vendor When the Job Gets Printed

After you've worked with a local paper distributor who has provided you with swatch books, samples and comps, as a professional courtesy, you should ask your printer to order the paper for that job from the distributor who helped you.

Jim Lenhoff, Johnston Paper, Cincinnati, Ohio

➤➤ PRICING
Save Money on Paper by Minimizing Your Publication Size

When printing a magazine or other publication in large quantities, an 8 × 11-inch (20.32cm × 27.94cm) format will result in a considerable savings over 8½ × 11 inches (21.59cm × 27.94cm). Why? An 8½ × 11-inch format allows for fewer pages on a sheet of paper and a lot of wasted trim. Reducing the width of the page by a half inch can add several more pages to each sheet. It may seem like a small amount, but those extra pages can result in a big cost savings for large runs.

➤➤ SCORING
When to Score

Sometimes printers will overlook the need to score a sheet if it's a relatively lightweight stock. However, solid ink coverage on coated paper will always result in cracking at fold lines, no matter what the weight of the paper. To prevent this from happening, have your printer score all fold lines before the piece is folded.

➤➤ PRICING
Waste Not, Want Not

You've come up with a project that fits nicely onto a large sheet of paper, resulting in no more than two inches of wasted trim. If you think that two inches of wasted trim may not be worth considering as printable real estate, think again. Standard business cards fall within this range as well as Rolodex cards. Beyond business applications, tags for client gifts can be printed on this supposedly "wasted" space.

➤➤ COLLABORATION
Purchase Your Own Paper for Small Runs

Don't ask your printer to buy paper for small, limited-quantity jobs. Most printers are accustomed to purchasing paper at wholesale costs in large quantities from local distributors. Small runs of letterhead (five hundred copies or less) can often be printed more economically on paper you purchase off-the-shelf from a paper retailer or online resource and take to a printer that specializes in quick-print or small-run offset printing.

➤➤ PRICING
Save Money by Avoiding Overruns

Slight overruns are a fact of life, but they still cost you more, and most of what you're paying for is the extra paper involved. This can amount to quite a bit of money if you're printing a publication. If you're truly in a situation where you can't afford to pay for printed paper you don't need, talk to your printer about keeping overruns to a minimum.

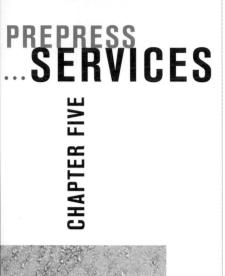

PREPRESS
...SERVICES

CHAPTER FIVE

➤ ➤ How to prepare digital files so they're easily converted to
plate and film, plus other tips from color houses, service
bureaus and printers' prepress departments.

>> MINI-INDEX

PREPARATION

COLOR
Don't Trust Your Monitor

When selecting color, don't trust your monitor's representation of CMYK and Pantone swatches. Additive or RGB color (color seen as projected light) is comprised of red, green and blue and is very different from subtractive color (seen as reflected light), which is a mix of cyan, magenta, yellow and black. Instead, choose the color you want to use from a swatch book and then select that color from the computer program you're using.

STOCHASTIC SCREENS
A Word of Caution on Stochastic Screens

Many printers claim they can print both stochastic and conventional screens at the same time. Seeing is believing. If your printer makes a claim like this, ask to see some samples of printed signatures. It's not impossible to print both, but it's also not easy.

Adapted with permission from "Tech Tips," by Constance J. Sidles, *HOW* magazine, February 1997

COLLABORATION
Ask What They Need Before You Deliver

Communication with your service bureau or your printer's prepress department is critical. Be sure you understand exactly how they would like your files to be set up. Although most service bureaus and printers' prepress departments have the capacity to output many different file formats and applications, we've found they prefer to receive QuarkXPress files. Some service bureaus and prepress departments only guarantee results with Adobe Type 1 Postscript fonts. If your job uses a True Type font, it's possible it won't RIP or print properly. Knowing these details can really help in the long run.

Gordon Mortensen, Mortensen Design, Mountain View, California

TEXT
Back Up Outlined Text Before It's Outlined

Although you can avoid output problems by converting your Adobe Illustrator and Macromedia FreeHand text to outline, you lose the ability to revise your text should an error be found at the last minute. To safeguard against this, copy your text to another document and save it before you convert the text to outline.

➤➤ ## COLOR
Printers: You Get What You Pay For

Digital color printers have improved over the years to the point where studio color laser printers can be purchased relatively inexpensively. But if high-quality color output is important to what you do, you may not want to be stingy when it comes to purchasing a color printer for your studio. Low-priced color printers tend to produce less accurate color. This may be fine when producing prints for in-house review, but if presenting accurate color comps to clients is important, you'll end up having to pay for service bureau output for your final comps.

➤➤ ## IMAGES
Minimize Links

To reduce output problems at your service bureau or printer, minimize the number of images you link between programs. For instance, avoid creating an image in Adobe Photoshop, adding graphics to it in Adobe Illustrator and then bringing it into a QuarkXPress document. It's much better to bring the Photoshop image directly into Quark and add the graphics in that program.

➤➤ ## COLOR
Use the Same Service Bureau for Reliable Color

Use the same service bureau on a regular basis and you'll find you will get more reliable results. Why? Because differences will always exist between your monitor and any given service bureau's color printer. You can compensate for those differences when you're accustomed to seeing the same discrepancies occur on a regular basis. You'll know exactly how much of an adjustment to make in your files to achieve exact color when your service bureau produces prints.

➤➤ COLOR
Acetate Overlays Mimic Colored Inks

Need to know how a design will look on various colored stocks you're considering? You could have your service bureau make the number of color prints required on each of the papers you're considering, but that can be expensive. Instead, have your service bureau make one color print and have a color photocopy made of it on transparent acetate. Overlaying the acetate print on the different colored stocks should give you a good representation of how each will look.

➤➤ IMAGES
Keep Anchor Points to a Minimum

Drawing programs such as Adobe Illustrator and Macromedia FreeHand will let you create curves and lines with anchor points that can be pulled and tugged to create shapes. Just remember that the more anchor points you add to an image, the longer it will take for your service bureau or printer's prepress department to RIP your file. The time involved in processing your file can often make a difference in your bill.

➤➤ COLOR
Make Sure All Spot Colors Are Present and Accounted For

Some desktop programs require that you define colors with the identical name that was used in an imported and placed EPS file or your output won't image properly. Always make sure that the colors used in imported Illustrator or FreeHand files appear in your page-layout program's color menu and that those colors use exactly the same naming convention used in the document imported. The same holds true for duotones, tritones and quadtones produced in Photoshop.

Adapted with permission from *The Bell Press Guide to Scitex Prepress*, published by Bell Press, Inc.

➤➤ TEXT
Tips for Styling Type

When styling a typeface as bold or italic, don't use the bold and italic style attributes from the style menu of the program you're working with. These may get stripped from your file when your work is processed by your service bureau or printer's equipment. Instead, select the bold and italic versions of the typeface from the font menu.

SCANNING
Don't Waste Memory on Unnecessary High-Res Scans

Many designers think that optimum scanning for print is 300 dpi. This is true for some print applications, but you can save memory and end up with a smaller file by scanning at lower resolutions if your image will be printed in a newspaper or other situations where a coarse halftone screen is used. When scanning images for print, the optimum resolution should be two times the lpi of the halftone screen used on your photograph. So if you're scanning an image that will be printed with 150 lpi screen, the 300 dpi rule applies. An image that will be printed as a 65 lpi halftone can be scanned at 130 dpi. One that will be printed as a 120 lpi halftone can be scanned at 240 dpi, and so on.

COLOR
Paint Feint

When designers need to separate original paintings, they often ask a photographer to shoot a high-quality transparency of the art. The transparency is usually easier for separators to work with, and nobody objects if you take it out of the frame.

Unfortunately, this technique introduces a new element into the reproduction process. Instead of working with the artist's real object, you're working with film that's one generation removed. The film itself is slightly biased in color fidelity, as is the lighting used by the photographer. When the separator tries to separate the transparency, she may have no idea what the artwork's original colors were.

To get around this problem, try propping a color bar at the base of the art so the photographer shoots it along with the art. The color bar should include a grayscale and several process-color targets. When the separator receives the transparency, she'll have a better idea of how to set up her scanner for optimum color balance.

Excerpted with permission from "Tech Tips," by Constance J. Sidles, *HOW* magazine, August 1996

IMAGES
How to Prevent Washed-Out Images

Light-colored four-color images can often appear washed out when they're printed. You can achieve purer color by removing contaminating colors from your image after it's scanned. Have your service bureau or whoever is working with your digital files go into the scan and remove dots of color that appear in the color separations that aren't required to create the color you're looking for.

➤➤ SCANNING
Scanning Line Art

With grayscale and color art, the resolution should be about twice the line screen—300 dpi resolution when the image is printed at 150 lpi, for example. But you need a higher resolution to keep black-and-white linework crisp. In theory, the resolution of the art should match the resolution of the output device. In practical terms, however, there is no point in going higher than 1000 dpi, even when you're sending the file to a 2450 dpi imagesetter. A higher scan resolution will only increase the file size—it won't improve the appearance of the finished piece.

Excerpted with permission from "Shortcuts," *Step-By-Step Graphics*, Vol. 15, No. 4, July/August 1999

➤➤ SIZE DIMENSIONS
Try Not to Size in a Page-Layout Program

Instead of scaling and rotating images in a page-layout program, we've found that you're less likely to encounter problems if you scale and rotate your images in Photoshop and then place them in the page layout program at exactly the size and angle you need.

Gordon Mortensen, Mortensen Design, Mountain View, California

➤➤ SCANNING
When Direct Scans Won't Work

Even if your image will fit on a scanning bed or can be easily wrapped around the cylinder of a drum scanner, some situations warrant shooting a transparency of your photo or art, rather than taking a chance on a direct scan:

- **If the surface is glossy, the scanner may pick up highlights and streaks, the result of reflective glare.**

- **Art produced on a heavily textured paper or board can cause the scanner to pick up shadows.**

- **Pastels, charcoal and other soft media often cause the scanner to read the color beneath the medium, particularly if a dark or medium-toned paper or illustration board is used, resulting in a washed-out image.**

➤➤ SIZE DIMENSIONS
When to Size in a Page-Layout Program

The usual rule that service bureaus cite is to scale vector images before placing them into a page-layout program because the final document will RIP faster if the scaling doesn't have to be calculated when the file is being rasterized. An exception, however, is if your file contains illustrations that use any of the brushes found in Adobe Illustrator: the Pattern, Scatter, Calligraphy or Art brush. If you scale artwork with these brushes in Illustrator, their effects can become distorted, so scale the final image after you have placed it into a page-layout program.

Adapted with permission from "101 Hot Tips," Publish magazine, September 1999

➤➤ QUARKXPRESS SHORTCUTS
Routine Printing in XPress

If you often create documents in QuarkXPress that don't fit the typical 8½ × 11-inch (21.59cm × 27.94cm) portrait orientation, a monthly tabloid-sized newsletter, for example, or lots of landscape-orientation brochures on legal-sized paper, consider setting up a print style to simplify the process of making laser prints.

Choose Print Styles from the Edit menu, click the New button, give the style a name and enter the settings you need. Once you've created a style, you'll find it in the pop-up Print Styles menu in the Print dialog box. All you need to do is select the style from the menu—no need to enter the dimensions, orientation or scaling information.

Excerpted with permission from "Shortcuts," Step-By-Step Graphics, Vol. 16, No. 4, July/August 2000

➤➤ STOCHASTIC SCREENS
Avoid Moirés With the Right Halftone Screen

If you're reproducing repetitive patterns such as herringbone or checks, you're likely to have a moiré occur when your printer or service bureau converts the patterned image to a halftone screen. Ask them to switch to stochastic screens. Because they have no repeating pattern, stochastic screens prevent moirés.

➤➤ COLOR
Spot Color Gradients

When you want to create a gradient that fades from a spot color to white, don't set white as the second color. If you do, the program—and this includes just about every graphics application there is—will transform the intermediary colors into CMYK mixes, not spot color tints. But if you specify 0 percent of your spot color for the white value, the gradient will fade perfectly.

Excerpted with permission from "Shortcuts," *Step-By-Step Graphics*, Vol. 15, No. 2, March/April 1999

➤➤ FONTS
Installing Fonts

Dragging a font you want to install to your closed System Folder instead of directly to the Fonts Folder will allow your Mac to automatically resolve conflicting font identities.

➤➤ SCANNING
Import Curves Into Your Scanner's Software

To get the best color and contrast in a scan, make a low-resolution scan, open it in Photoshop and make all color and contrast improvements with Photoshop's curves feature. Save the curves and load them back into your scanner's software. Now your scanner will use the color-corrected curves, creating a better high-resolution file as a result. If you're scanning multiple images with a similar color range, you can use the same curves, and you can always save the curves and reload them on demand. This technique is especially helpful when your scanner is set up on a secondary workstation with a smaller, older monitor that makes color difficult to judge. - Katrin Eismann

Excerpted with permission from "101 Hot Tips," *Publish* magazine, September 1998

➤➤ COLOR
Create Spot-Color-Only Files

To create an image file in Photoshop that will separate into spot colors only (as opposed to the four process colors plus a spot color or two), convert your image to Multichannel mode, delete all channels other than the spot-color ones and save the result as a Photoshop DCS 1.0 file. - Anne-Marie Concepción

Excerpted with permission from "101 Hot Tips," *Publish* magazine, September 1999

➤ ➤ COLOR
Achieve Rich-Looking Black-and-White Photos

Scanning a black-and-white photo as a four-color photo yields a richer black-and-white image, but it can also wreak havoc on press. Any shift in color can cause a black-and-white photo to be tinged with yellow, cyan or magenta.

If you want to increase depth by achieving richer blacks in your black-and-white image, it's better to have the photo printed as a duotone or tritone with all black inks. A black touch-plate will also deepen the shadows, or use a technique called double-dot, where two plates that print black are used.

➤ ➤ TEXT
Creating Really Big Type

To create really big type (up to 1,300 points), try this: Size the type to one half of the final size you want. For instance, if you want 800-point type, size it to 400. Select the text. Press Command/T to get the type specs. Change the position to Superscript. Click on the option button. Change the superscript size to 200 percent. Change the superscript position to zero. Click OK.

➤ ➤ FONTS
Use Type 1 Fonts

Experience has shown that True Type fonts don't always image correctly on modern image-setting equipment. If you happen to have True Type fonts in your system, it's best to replace them with Type 1 versions to avoid problems. Be careful not to throw away the fonts that came with your system (Symbol, Courier, Geneva, Chicago, etc.) as some of them are needed by the computer to accomplish everyday tasks.

Excerpted with permission from *The Bell Press Guide to Scitex Prepress*, published by Bell Press, Inc.

➤➤ TEXT
Reversed Type Needs to Be Choked and Spread

If you're having four-color separations made of reversed type, your service bureau may not automatically choke or spread the reversed type. With choking and spreading, type is reversed out of the most dominant color in a size that's slightly smaller than the other colors. When the job is printed, the extra white space around the reversed type in the less-dominant colors is covered by the ink of the most dominant color. This ensures that the type stays white, even if colors are out of register. Without choking or spreading, type may end up printing in one or more of the four colors rather than white.

➤➤ COLOR
What Program Works Best for Gradients?

Illustrator, FreeHand, Photoshop and QuarkXPress will all let you make gradients. However, if you want to prevent banding when your document is RIPed, Photoshop is the best program to use for gradient blends. Even if you're creating your document in one of the other programs, make your gradient in Photoshop and then bring it into the other program as an image file.

Mark Sferas, Master Graphics, Reseda, California

➤➤ SCANNING
Make Sure Your Scans Are as Clean as Possible

When scanning photographs or illustrations, check the print surface as well as the glass on your scanning bed for dirt and dust. Scanners often pick up dust and even fingerprints that aren't readily visible to the naked eye. Unless you check, these imperfections will be digitized along with your image, requiring retouching of your final scan.

➤➤ RULES
Don't Use "Hairline" Rules

The "hairline" setting tells the postscripting device to output the finest rule it can. This might look fine on your laser proof, but "hairline" can be interpreted differently on a high-resolution imagesetter. Define thin rules numerically, such as "0.5 pt."

Adapted with permission from *The Bell Press Guide to Scitex Prepress*, published by Bell Press, Inc.

FRAMES
Don't Use Rules for Frames

It's extremely difficult to create perfect corners (even though they may look correct on your monitor). Use the frame option with your page-layout program, or create the frames in vector-based drawing programs such as Illustrator or FreeHand.

Adapted with permission from *The Bell Press Guide to Scitex Prepress*, published by Bell Press, Inc.

SCANNING
Save Money on High-Res Scans

When speccing reductions and enlargements on photos or transparencies that need high-resolution, four-color separations, try to designate as many photos as feasible for the same percentage so they can be ganged to save money. For instance, instead of reducing five photos as three at 32 percent and two at 38 percent, consolidate them so that all five are shot at 35 percent.

FONTS
Stay Away From the City

When setting text, avoid using fonts with city names such as Chicago, Geneva and New York. These are True Type fonts created for computer use as opposed to Type 1 fonts, which are created for print and publication.

Geneva **Chicago** Monaco

City fonts such as Geneva, Chicago and even the "nation" font Monaco can cause problems when they're used for print applications.

➤ ➤ FONTS
The Invisible Font

You get a message that a font is missing when you open up a document you've been working with, but you replaced that font with a new one. Why does the program continue to ask for the font? Check your document to see if there are any returns or spaces within the piece that may still retain the style attributes of the original font, then delete that font from your document. If you don't do this, when the file is opened by your printer's prepress department or service bureau, it will ask for these fonts. Then they will call and request fonts that you didn't intend to be there in the first place.

Gordon Mortensen, Mortensen Design, Mountain View, California

➤ ➤ FONTS
Convert Fonts to Paths If They're Part of an Image File

If you've created a project in a page-layout program, when you check your font usage you will get a record of all of the fonts you used in the program, not the fonts that were used in any images that were created in Adobe Illustrator or Macromedia FreeHand and then placed in your document. You can include the fonts, if you remember them, that were used for the image, but a better way of dealing with this is to eliminate the need for the font altogether by converting your type to a path. To do this, choose Outline from the type menu.

Type as Text

Type as Outlined

Fonts converted to Outline in a drawing program are changed from text to paths so that, when they're brought into another program, they're read as images rather than fonts.

➤➤ COLOR
Pump Up Dull Colors in Photoshop

Sometimes an RGB file loses its luster when converted to CMYK. Simply increasing the color saturation in such a file may cause an unwanted increase in contrast and lead to harsh color breaks. To boost the saturation without adding unwanted contrast, add a Hue/Saturation adjustment layer in Photoshop with the mode set to Color. Adjust the Saturation slider until the color is right (or even slightly exaggerated), without worrying about any changes in contrast. If you exaggerate the color, reduce the Opacity of the adjustment layer in the Layers palette until it looks the way you want. - Linnea Dayton and Jack Davis.

Excerpted with permission from "101 Hot Tips," *Publish* magazine, September 1999

When converting an RGB image file to CMYK, adding a Hue/Saturation layer will help preserve its quality.

COLLABORATION
Don't Be a Control Freak

A few years ago, when many designers sought ultimate control, the assumption was, "If the computer is capable, then, by gosh, I must do it!" Not anymore. Now there seems to be a level of acceptance that a designer doesn't have to do it all—it's OK to farm out processes such as trapping and color correction. Maybe it's an acknowledgment that you can be a jack-of-all trades, but then you're also a master of none. In most cases, outsourcing is a smart idea. Trapping requires knowledge of the press, so it's usually far easier for a vendor to handle the task.

Excerpted with permission from "The Future of Proofing," by Debbie Johnson, *HOW* magazine, June 1998

RASTER IMAGE PROCESSOR
Save Time and Cash: RIP Once

A Raster Image Processor (RIP) crunches the data from your file for output to a proofer, imagesetter or other digital device. If you send a file to a low-end output device for a preliminary proof and then request a proof from a Kodak Approval System, it's likely that your vendor would have two RIPs—one for each output device. The RIP-once trend makes sense for a number of reasons. To RIP a file takes time; if the vendor has to do this only once, time is saved and the workflow is streamlined. Second, with multiple RIPs, there's a chance that each RIP will interpret digital data a bit differently, so the trend of a one-time RIP sent to any number of output devices should help preserve data integrity.

Excerpted with permission from "The Future of Proofing," by Debbie Johnson, *HOW* magazine, June 1998

OUTPUTTING
Printouts Prove Your Digital Files Can Be Printed

Never hand off a digital file to your service bureau or printer without including a black-and-white or color laser print with your job. In addition to serving as a visual reference, your print serves as proof to the vendor that the job can be printed. This can be especially important in the case of a color job when color separations need to output from your digital files. If your files can't be separated for your own color printer, chances are good that your vendor's printer won't be able to print it either.

Karen Vatter, MPI, Cincinnati, Ohio

►► COLLABORATION
Marking Up Color Proofs

If your service bureau or printer is making adjustments on a color proof, use language that they can understand and execute.

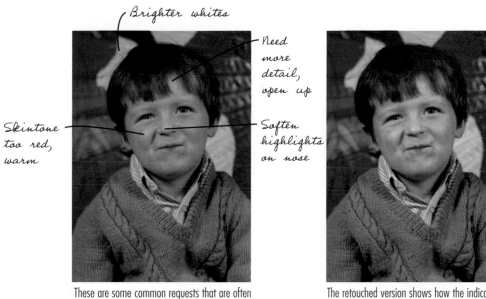

These are some common requests that are often made on marked up proofs.

The retouched version shows how the indicated alterations yielded an improved image.

►► PREPARATION
Back Up Your Original

Send a copy of your disc and keep the original in a safe place. There's always a possibility that media may get damaged in transport and become unusable. Your backup copy is your only insurance.

Adapted with permission from *The Bell Press Guide to Scitex Prepress*, published by Bell Press, Inc.

►► OUTPUTTING
Check for Missing Items by Opening Your Files on Another Computer

"Collect for Output" isn't always a failsafe way of ensuring that you have all the images and fonts that you need for a job. Instead, take your electronic files for the job and open them on another computer. If an image isn't present or a font is missing, you're likely to catch it there, before you take your job to the service bureau or printer.

Gordon Mortensen, Mortensen Design, Mountain View, California

►► COLLABORATION
Proofs and Color Corrections

Communication is the key to "correct" color corrections. Many designers continuously send separations back with new requests to make slight adjustments. This is a costly procedure that, if the separator doesn't pass the cost on to the designer, can erode the relationship. It's the designer's responsibility to make all requests for corrections or adjustments in as few go-arounds as possible. Go over the original with the separator before it's scanned to ensure the best possible results with the first scan.

Adapted with permission from "Making the Most of Your Color Seps," by Steven W. Frye, *HOW* magazine, August 1999

►► OUTPUTTING
Label Your Discs

Put your company name, address and phone number on your discs and disc containers so your service bureau or printer can reach you if any questions arise. If there is more than one disc per job, indicate "one of three," "two of three," etc. This also makes it easier to return your discs to you after your job has been printed.

Adapted with permission from *The Bell Press Guide to Scitex Prepress*, published by Bell Press, Inc.

►► PROOFING
Separation Check: Tips for Bringing Details Into Focus

When dealing with color separations of transparencies that appear fuzzy and out of focus, it's often hard to judge whether or not the proofs you're viewing are the result of a poor scan or a poor original. Check the details of your original first with a loupe. Be sure eyes, hair and other detailed areas are in focus. This is especially important if there's a chance that you're dealing with a duped transparency that may have been reproduced poorly. If the originals are in focus, ask your color separator or whoever has created your scans to check that unsharp masking was applied during the separation. Increasing unsharp masking can help bring details into focus. Lastly, but most important, make sure the proof is in register. To check this, look at the color bar on the edge of the proof.

➤➤ OUTPUTTING
Preflight Software Can Help You Catch Output Problems

Software packages often used by service bureaus such as Markzware's Flight Check and Extensis PreFlight Pro can help designers collect fonts and images by preflighting their own files before they're sent to a service bureau or printer.

Kevin Sullivan, dBest, Cincinnati, Ohio

➤➤ PROOFING
Know Your Proof System

There are a lot of proofing devices and many types of proofs to choose from. Each offers advantages over other methods for checking certain types of print jobs. Here's a list of some common proofing systems and when they're most likely to be used.

- Single-color paper proofs (blue lines) — Used for checking copy, type, size and position of all images, artwork, pagination, etc. Not suitable for judging color.

- Analog proofs (Chromalin, Matchprint) — Used for checking color accuracy. Made by exposing light-sensitive material through film and laminating them together. Not suitable for direct-to-plate printing or any jobs printed on a digital press.

- Digital proofs (Fiery, Tectronix, Rainbow, Iris) — Are created using a variety of technologies. Dye-sublimation and laser ablation proofs use either light (laser) or heat (thermal) to transfer material onto a carrier. Ink jet proofs are made by spraying small droplets of colored liquid directly onto paper. Electrostatic proofs are created by affixing charged particles of powder directly onto paper. Suitable for direct-to-plate printing and jobs printed on a digital press.

Mark Sferas, Master Graphics, Reseda, California

➤➤ FONTS
Avoid Font Incompatibilities

When handing off your digital files to your service bureau or printer, be sure to include all of the fonts used on the job. Your printer may have some of the fonts, particularly if you've used a common typeface, but include them anyway just in case the font he has was made by a different manufacturer.

Dan Fein, Diversified Screen and Digital Printing, West Conshohocken, Pennsylvania

➤➤ OUTPUTTING
Deliver Only What's Needed

We've found there's less confusion and fewer problems when we deliver clean electronic files to our service bureau or printer. Before finalizing the job check for the following:

- Delete any extraneous picture/text boxes.
- Delete any extraneous data on the pasteboard.
- Get rid of extra guides.
- Delete extra colors not being used. (This is very helpful when using multiple spot colors and serves as a check that you have exactly what you want in your file.)
- Make sure all links are updated.
- Make sure all of your images are in the appropriate file format for the program you are using.
- Only include the fonts that are needed. Delete any fonts that might have been used early on in the project but won't be used in the final version.

Gordon Mortensen, Mortensen Design, Mountain View, California

➤➤ PORTABLE DOCUMENT FORMAT (PDF)
Working With PDF Files

There's a lot of confusion about the proper way to prepare PDF (Portable Document Format) files that allow you to e-mail your digital files in a page-layout program to your printer. We recommend that our clients use the plug-in EZ-PDF because the user can simply use the Print command and choose Prepress in the print dialog box. The plug-in will read the user's source file, launch Adobe Acrobat Distiller and handle the rest automatically. EZ-PDF embeds all fonts and graphics in one compact file.

Mark Sferas, Master Graphics, Reseda, California

➤➤ COLOR
Check Color Before Finalizing a Job

It's easy to get confused when you're using colors in your piece that are similar to the RGB color palette that comes with your computer. For instance, you've designed a piece with one spot color. When you started, you used the red that's on your computer palette, but then you switched to a Pantone red as the job progressed. Although they look different when they're printed, the two reds look exactly the same on the screen and when printed on your studio's color printer. Problems occur when you take the job to the printer and the job is handled as a three-color job because three sets of films and plates are generated. To prevent this from happening, check Make Separations when you go to print the job on your studio printer. That way you'll be able to see each color printed. You can even check color this way on a black-and-white printer.

OUTPUTTING
Print a Directory of Your Job

Before you deliver a job to your service bureau or printer, print out a directory of everything you've loaded onto your Zip disc by going into the Finder mode on your Macintosh computer, double-clicking on your Zip disc icon and selecting Print Window under File. When you include this directory with your Zip disc, your vendor will be able to see all of the files that are involved with your job.

Gordon Mortensen, Mortensen Design, Mountain View, California

Name	Size	Kind	Label	
▢ Cover	27K	QuarkXPress document	—	
▷ ▢ Fonts	—	folder	—	
▢ Interior layout	707K	QuarkXPress document	—	
▷ ▢ Photos	—	folder	—	

Communique

Sending a printout of your job files, with components in labeled folders, lets your service bureau or printer know what you've included on your disc.

PROOFING
Always Supply a Marked-Up Hard Copy Proof

When supplying a hard copy proof, indicate special instructions like color breaks, overprints or knock-outs. Show which photos are FPO, where bleeds are or any other pertinent production info that will clarify your intentions to prepress personnel.

Excerpted with permission from *The Bell Press Guide to Scitex Prepress*, published by Bell Press, Inc.

...PRINTERS

CHAPTER SIX

6

>> How to get the most from your printer, negotiate trade-offs for services, plus technical tips on how to prepare and check jobs to ensure on-press success.

PREPARATION

➤ ➤ ## PRICING

Reap Rewards From Designing a Printer's Self-Promotion Piece

If you've been working with a printer for a while, and there's mutual respect for each other's work, you can both benefit from designing your printer's self-promotion piece. In the case of Byrum Lithographing, the self-promotional brochure we designed showcases Byrum's printing capabilities and a lot of fancy techniques that we often don't have an opportunity to take advantage of when we design for other clients. We had a lot of fun coming up with a theme and visuals that would play up these techniques in the most dynamic way. Because the brochure's audience consisted of designers and other creative professionals, we had a lot of creative latitude—it gave us the chance to do some of our best work. The piece also brought us recognition—it's been featured in several design publications, including *The Best of Brochure Design*. In exchange for our work, Byrum gave us a credit line and printed our firm's self-promotion at no charge.

Eric Rickabaugh, Rickabaugh Graphics, Columbus, Ohio

Rickabaugh Graphic's brochure is a collection of movie posters that focus on a variety of Byrum Lithographing's printing techniques. In addition to four-color printing, the posters feature large areas of solid match colors, metallic varnishes and metallic inks, and a combination of high-gloss and dull varnishes.

➤➤ PRICING

Include These Items With Your Printing Bid Requests

Before requesting printing bids, you should compile information about your project in a request for proposal package for printer candidates. Try to make your package as comprehensive as possible so all bidders receive the same information and none need to ask any further questions. Be sure to include:

- A specification sheet listing all prepress, ink, paper, folding, binding, finishing and distribution requirements.
- A project outline showing a production and distribution schedule.
- Your list of goals and priorities.
- A sample, mock-up or schematic of the product.
- A contact list of involved personnel with respective phone, fax and e-mail addresses.
- A request sheet asking for samples, references and pricing.

Excerpted with permission from "How to Find a Printer Match Made in Heaven,"
by Steven W. Frye, *HOW* magazine, April 1999

➤➤ SWATCHBOOKS

Keep Swatchbooks Under Cover

Sunlight can have a dramatic impact on inks, causing them to fade in a short period of time. Swatchbooks left on a window ledge or anywhere where they are exposed to sunlight will become altered and unusable within a year. To prolong the life of your swatchbooks, keep them in a drawer and take them out only when you need to use them.

➤➤ BINDING

Know How Many Signatures Your Bindery Can Accommodate

Before your publication is sent to a bindery, check to see how many stations or pockets are available to bind your job. Large publications such as catalogs may require more signatures than the bindery can handle. If this is the case, alert your printer so that smaller signatures can be combined into larger ones.

• • • • • •

➤➤ PRICING
Don't Expect All Printers to Be Able to Bid the Same Job Competitively

Learn the capabilities, strengths, weaknesses and specialties of your vendors. When I was manager of a company's in-house design department, I was flabbergasted by the purchasing department's bidding procedure, which lumped together all printers in one category so that quick-print shops would bid against full-service companies with six-color presses. One of the first things I did was meet with each vendor and determine their capabilities. I found that small shops with small presses could bid lower on stationery and small-run, limited color projects than full-service printers and that the bigger shops could offer better prices on full-color, large-run jobs. I then grouped vendors with similar capabilities for fair price comparisons.

David Langton, Langton Cherubino Group, Ltd., New York City

➤➤ COLLABORATION
Evaluating Vendors

For us, it's critical to work with printers who really know their business and are not just "selling." In order for someone to get on our vendor list, they must demonstrate a clear understanding of printing and stand behind their work. The best test is to see how they handle the situation when things go wrong (and in printing, things will at some point go wrong). Does the printer immediately blame you or does he find solutions? The printer who comes up with answers to on-press challenges gets our repeat business.

David Langton, Langton Cherubino Group, Ltd., New York City

➤➤ COLOR
Don't Try This With an Ordinary Printer

When we contracted with Demkin Printing to design their self-promotional brochure, they wanted to showcase their printing capabilities with a demanding piece that warranted special production considerations. To comply, we came up with a design that required the printer to trap and maintain tight registration on five match colors and maintain color consistency on a combination of coated and uncoated papers. (See photo on the next page.) Because Demkin specializes in custom binding, the brochure also includes a number of short pages. Designers who see the piece appreciate the challenges it presented.

David Langton, Langton Cherubino Group, Ltd., New York City

Demkin needed to carefully trap and maintain tight registration on pages that featured a background of different colored rules.

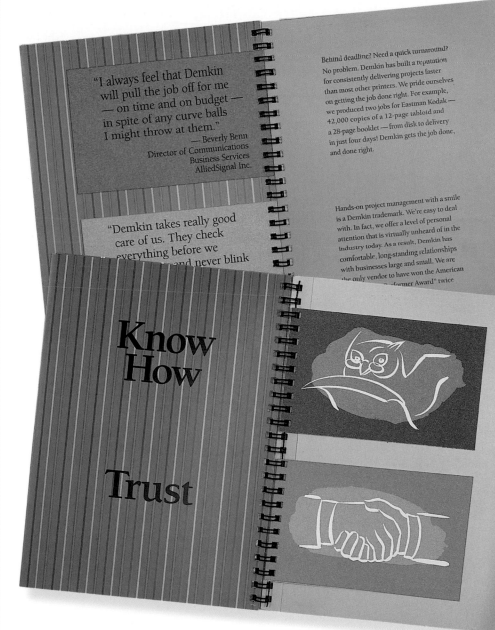

"I always feel that Demkin will pull the job off for me — on time and on budget — in spite of any curve balls I might throw at them."
— Beverly Benn
Director of Communications
Business Services
AlliedSignal Inc.

"Demkin takes really good care of us. They check everything before we ... and never blink

Behind deadline? Need a quick turnaround? No problem. Demkin has built a reputation for consistently delivering projects faster than most other printers. We pride ourselves on getting the job done right. For example, we produced two jobs for Eastman Kodak — 42,000 copies of a 12-page tabloid and a 28-page booklet — from disk to delivery in just four days! Demkin gets the job done, and done right.

Hands-on project management with a smile is a Demkin trademark. We're easy to deal with. In fact, we offer a level of personal attention that is virtually unheard of in the industry today. As a result, Demkin has comfortable, long-standing relationships with businesses large and small. We are the only vendor to have won the American ... -former Award" twice

Know
How

Trust

• • • • • •

➤➤ # BINDING
Which Binding Method Is Best?

Your optimum choice for binding depends on the type of publication you're producing, its size, the number of pages and the budget involved. Here is a list of some of the most commonly used types of binding, their advantages and limitations:

Saddle Stitched:

- Saddle stitching is among the least expensive binding options available for a wide range of quantities.

- Crossovers (designs that cross a spread) will align.

- Saddle stitching works best for publications with a relatively small number of pages. Most binders recommend against saddle stitching for books larger than ¼ inch (0.64cm) thick.

- Saddle-stitched books creep. The pages nearest the center will extend beyond the cover, meaning that after they're trimmed, the outer margins will be narrower than pages closest to the cover. Make sure your printer makes allowances for creep when pages are impositioned for signatures.

Side Stitched:

- Side stitching is one of the least expensive and most durable binding methods available. It works on brochure thicknesses ranging from ¹⁄₁₆ inch (0.16cm) to 1 inch (2.54cm).

- Side-stitched brochures can accommodate glued covers for a more finished look.

- This binding option works well for publications that include tearouts, which can be perforated so that the spine stays intact.

- When setting up pages, create a wider inner margin to accommodate the allowance needed for the stitches. Inner margins should be at least 1 inch (2.54cm).

- Pages won't lie flat when opened.

Perfect Bound:

- Requires a minimum thickness of ¹⁄₁₆ inch (0.16cm), maximum thickness of 2⅜ inches (6.03cm).

- Allows for printing on spine.

- A good choice for moderate to high quantities where it tends to be less expensive than mechanical binding.
- Crossovers can be tricky, depending on printing process, thickness of paper, number of pages in a signature and folding accuracy when signatures are folded.

Spiral:

- Works well for manuals and other publications that need to lie flat.
- Spiral coils are available in metal and plastic in a wide range of colors.
- Because pages jog when opened, crossover designs won't align.
- Works for a wide range of materials in addition to papers such as plastic and laminates.
- Allows for easily binding interleaf or short pages.
- Well suited for short runs.

Double Wire or Wire-O binding is similar to spiral binding in many respects, except for the following:

- More finished look than spiral bound.
- Allows for nearly perfect alignment between pages, making design crossovers easier to achieve.
- Can be cost-effective for larger runs.

Plastic Comb:

- Works well for manuals and other publications that need to lie flat.
- Offers greatest capacity of pages of any mechanical binding.
- Can be reopened to insert additional pages.
- Economical for short-run projects, but hand assembly can make it costly for large quantities.
- Facing pages align, making crossover designs possible.

LETTERPRESS PRINTING

Letterpress Printing: An Offset Alternative

Letterpress printing can offer design options that aren't available within the realm of conventional offset printing. However, there are some limitations involved. Here are some considerations to keep in mind when determining whether letterpress is a viable printing option for your project:

- Letterpress can be used on many types of paper surfaces, such as handmade papers, chipboard and other industrial papers unsuitable for offset printing.

- Because letterpress runs one color on press at a time, it's not a practical option for printing four-color process where exact registration is required.

- Letterpress leaves the greatest debossed impression on soft, absorbent papers.

- Letterpress can be used on coated stocks as well as uncoated stocks.

- Letterpress can be used for reproducing halftones, but the halftone screens must be fairly coarse—110 lpi or smaller.

- Because it's a time-consuming process, letterpress is ideal for short runs but not rush jobs.

Letterpress printer and designer Bruce Licher of Independent Project Press combines antique borders, metallic inks and unusual papers in his letterpress designs.

➤➤ PRICING
Long-Term Relationships Pay Off in the Long Run

Some designers consistently shop for the lowest bid when determining which printer will get the job. But I've found it pays off in the long run to develop long-term relationships with just a few printers, to trust that their prices are fair and to depend on them for the bulk of your work. Aside from getting good service that you know you can rely on, a good printer who's accustomed to working with you can often offer suggestions that will help you come up with a better printed piece. Printers who get a steady stream of business from you will also be more likely to grant favors when you need them, pushing a rush job to the head of their work schedule or not charging for problems, even if they're your fault, that require extra time in prepress or on press.

John Baxter, Acme Design, Wichita, Kansas

➤➤ PREPARATION
How to Avoid On-Press Challenges With Four-Color Publications

- Try to design easy-to-print pages whenever you can.
- If possible, eliminate in-line color conflicts when you do your original design.
- Try to stay away from difficult traps.
- Avoid crossovers on different signatures.
- Don't create color from multiple screen tints (anything more than two process colors).

➤➤ COMPOSITES
Every Publication Needs a Dummy

When designing any perfect-bound publication, have your printer make up a bulking dummy made to the size and page count of your publication and from the interior and cover stock you plan to use. A bulking dummy will allow you to see how wide the spine will be, so you can set up art to fit these specifications. It will also let you see how much of each page's interior margin will be lost in the bound edge, enabling you to make margin allowances and exact adjustments for image and headline crossovers.

➤➤ IMAGES
Ensure Image Success On Press

If the design calls for a halftone near or surrounded by a solid area, tell the printer ahead of time. Depending on the press and number of colors you're running, he may be able to split the solid area from the halftone into two plates, enabling you to run the solid darker and fuller without plugging the halftones.

Excerpted with permission from "On Press With Success,"
a joint project between Strathmore Paper and Wright Communications.
Available free from Strathmore Paper. (800)423-7313

➤➤ PRICING
Factor in Long-Term Usage When Budgeting for Die Costs

Dies for embossing, foil stamping or die cutting can be expensive, but their production is largely a one-time expense. Once you've paid for the labor involved in making them, additional applications usually cost about the same as a one-color press run.

➤➤ PRICING
Getting Estimates and Bids From Printers

We find it useful to wait until the look and feel of the job is 90 percent established before we start soliciting bids and estimates from printers. Since design often changes, the parameters of an estimate could change several times during the course of the design. It's counterproductive to request an estimate and then change the specs several times.

Once we've gotten to the 90 percent point, we give the following to the printers bidding on the job:

- A storyboard and key spread that clearly represent the piece.
- Mark-ups of a key spread to show color breaks, bleeds, folds, custom die cuts, etc.
- An estimate form with detailed specs that we've developed. This is modified per job depending on quantity, size, color, paper, etc.

Gordon Mortensen, Mortensen Design, Mountainview, California

SILKSCREEN PRINTING
Guidelines for Silkscreen Printing

Silkscreen printing is your best option for printing on bulky and/or hard-to-print surfaces such as metal, vinyl, handmade and industrial papers, cloth, etc., as well as printing directly onto objects and garments. Here are some considerations to keep in mind:

- More time-consuming than offset, screen printing is good for short runs of 2,000 or less.

- Ideal for printing pieces too large for offset, such as posters that may also benefit from the even, brilliant color that can be easily achieved through screen printing.

- Although halftones and color separations can be printed, they should be reproduced at a screen size no finer than an 85-line screen for smooth-surfaced paper and a 55-line screen on textured paper or cloth.

- Rules should be no thinner than 2 points.

- Traps need to be larger than with offset, often ⅛ inch (0.32cm) or more. Consult with your printer on whether or not you will create trapping, and if so, what the allowance should be.

- Tight registration is difficult to achieve, especially on cloth.

- Because silkscreen inks are highly opaque, they overprint one another without bleeding through, allowing for the printing of light colors on a dark substrate.

John Sayles of Sayles Graphic Design achieved a fine-art quality by screen printing this poster on blotter paper, an unusual stock that prohibited its printing on an offset press.

COLOR
Color Matching for Comps

Printing a piece that uses match colors on your studio's color printer will often result in a color comp that's not accurate to the color you will experience on press when the piece is printed. To create a comp to show my clients that's as close a match as possible to what their piece will look like when it's printed, I color test my desired palette before building my document. I start by setting up a color test page with small blocks of color based on the Pantone matching formulas given for each color in their color swatch guides. I use their Process Color System Guide for converting match colors into process colors and print out the first set of swatches to gauge where color adjustments need to be made. I then adjust the percentages of the colors and repeat this process until I have simulated the desired colors as closely as possible. Once I have created these colors, I use them in the document for all the comp phases until I am ready to produce the final mechanical. At this point, I trade out all of the comp colors for the PMS colors.

Tricia Rauen, Treehouse Design, Los Angeles

PRICING
Cost Considerations to Keep in Mind

Beware of the printer with the cheapest price. I've found, more than once, that low prices were the result of internal problems, such as printers that have a lot of "down time" because of a lack of business. The reason they lacked work was because their customers were dissatisfied and no longer went there. Check references. Ask other print buyers what they like and don't like about particular printers.

Excerpted with permission from "How to Find a Printer Match Made in Heaven,"
by Steven W. Frye, *HOW* magazine, April 1999

COLLABORATION
Bring Your Printer into the Early Stages of Project Planning

When we get a new project, we call in a few printers early on before specifications are complete and discuss possibilities with them. The good printers know how to configure the job to save paper and money. They also know the availability of paper, which inks dry faster, when scoring is needed and other production details. You can use their experience to help you create a better project.

David Langton, Langton Cherubino Group, Ltd., New York City

➤ ➤ **PRICING**
Trade Design Services for the Printing You Need

Doing the design for a local printer's capabilities brochure allowed us to get our holiday self-promotion printed at no charge.

Stan Evenson, Evenson Design Group, Culver City, California

Evenson Design Group's holiday self-promotion was printed in exchange for design services the firm offered their printer.

➤➤ ## DRAWDOWNS

Custom Drawdowns Ensure On-Press Success

To ensure the best printing quality possible, before we send a job to the printer, we create a test sheet that tests color, type, sizes and color variations as a drawdown on the paper stock we've selected. We use this process on most printed pieces, and it has been enormously helpful for clients, designers and printers because it significantly reduces the chance of errors.

Jennifer Cloud, The Leonhardt Group, Seattle, Washington

The Leonhardt Group created this test sheet as a typical representation of the many image, color and type variations that appear in its annual report design for InfoSpace.

PRICING
Cost-Saving Factor for Publications

Plan a third color on a two-color job or a fifth color on a four-color job so that only one side of a signature will be printed with that color. Have your printer make up a dummy signature so that you can determine which pages will have color and which won't.

BINDING
Page Impositioning on a Perfect-Bound Brochure

Page impositioning is critical on perfect-bound jobs because the covers must run parallel with the grain. Unfortunately, sometimes this requires a less efficient use of paper. For example, when printing covers for an 8½ × 11-inch (21.59cm × 27.94cm) perfect-bound book with the grain parallel to the spine, you will only fit three covers on each sheet for most standard paper sizes [23 × 35 inch (58.42cm × 88.90cm), 25 × 38 inch (63.50cm × 96.52cm), 26 × 40 inch (66.04cm × 101.60cm)].

Cross-grain covers present problems, including cracking and wrinkling on the spine. However, if you are printing the cover on an uncoated text weight paper or on a lightweight cover, and if there is no ink coverage on the spine, you may be able to print your job four-up. Ask your binder to test the paper before you determine the page imposition.

Excerpted with permission from "Via Basics: Binding," by Via. Available free from Via. (800)892-5467

PRICING
Negotiating Costs With Your Printer

Don't negotiate costs until you have found the best printer for your job. Negotiating prices too early in the process only makes things more difficult. Instead of talking money with all of your potential printers, negotiate with the one printer you really want. Years of print buying have taught me that this approach results in greater reductions in price. If a printer feels you're pitting his prices against those of other printers, he may get defensive and be hesitant to lower costs. On the other hand, if he knows he's the only printer you're seriously considering, he'll be more likely to adjust costs to close the deal.

Excerpted with permission from "How to Find a Printer Match Made in Heaven," by Steven W. Frye, *HOW* magazine, April 1999

➤ ➤ COLOR

Maximize Your Color on a One-Color Run

To get three colors for the price of one, consider using a split fountain, a technique where two colors of ink are used in the same ink tray so they blend on press to make a third color. Here are some considerations to keep in mind when using a split fountain:

- **To achieve a proper split fountain technique, your printer needs to remove the oscillators (the two rotating cylinders that mix the ink) off the press he's using.**

- **Good for short runs only (five hundred impressions or less). As the press runs, the inks eventually become muddy and lose their brilliance.**

Jackson Boelts, Boelts Bros. Associates, Tucson, Arizona

These posters designed by Boelts Bros. take advantage of a split fountain run to create a colorful, blended effect on each poster's background.

➤➤ **BINDING**

How to Create a Spine on a Spiral-Bound Brochure

You can create a cover (and printable spine) for a double loop wire-bound book by folding the back cover from the spine, punching it at the fold and then inserting the wire. The cover is then folded back again to create the spine and front cover. This method conceals the wire on the front cover and spine, but the wire will show through the back cover.

Excerpted with permission from "Via Basics: Binding,"
by Via. Available free from Via. (800)892-5467

➤➤ **PRICING**

Standard Business Practice for Overruns and Underruns

Overruns or underruns should not exceed 10 percent of the quantity ordered. The printer will bill for the actual quantity delivered within this tolerance. If the customer requires a guaranteed quantity, the percentage of tolerance must be stated at the time of quotation.

Excerpted from the "Graphic Communications Trade Customs and Business Practices."
The complete list can be acquired by contacting Printing Industries of America (PIA)
at 100 Dangerfield Rd., Alexandria, VA 22314. (703)519-8100

➤➤ **BINDING**

Is Your Publication Being Printed in Signatures?

Perfect-bound and saddle-stitched brochures require binding signatures, and signatures are comprised of four or more pages. If you can't commit your publication to a page count that's divisible by four (e.g., twenty, twenty-four or twenty-eight pages) eliminate perfect-bound and saddle-stitched binding from your list of binding options.

➤➤ ## PRICING

Cost-Saving Tip for Newsletters

For two-color or four-color publications such as newsletters, where black is used for text and accent colors are used consistently on a masthead or other graphic elements from one issue to the next, you can save money by having a large quantity preprinted with just the colored elements. Have your printer pull the blanket on the black after the print run is completed for the first issue and print additional copies with nothing but the accent color. When future issues are ready to be printed, these colored "shells" can then be printed with information pertinent to each issue in black, resulting in savings from printing these issues as a one-color job versus a two- or four-color job.

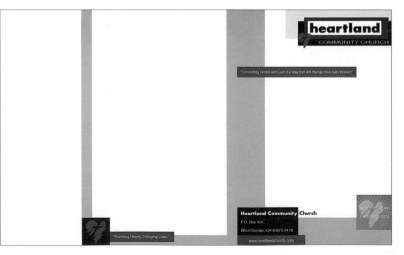

Heartland Community Church in West Chester, Ohio, saves money on their newsletter by printing a four-color "shell," which can then be used for various one-color press runs in the future.

FOLDS
Know Your Folds

When talking to printers about the type of fold you need, it helps to know the language used to describe different types of folds. Here are some examples of typical fold configurations:

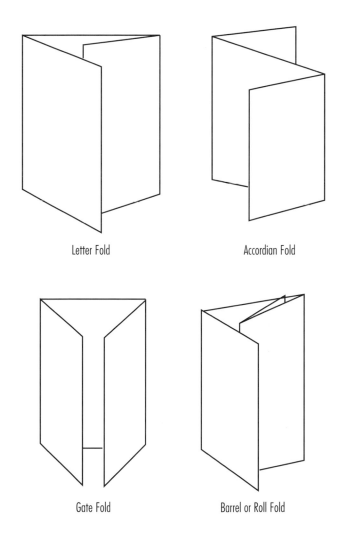

Letter Fold Accordian Fold

Gate Fold Barrel or Roll Fold

➤➤ BINDING
Loop Stitch Brochures for Binders

Loop stitching is a variation on saddle stitching where the stitch, or wire, is formed into a circular loop that sticks out beyond the spine in a finished book. The loops slip onto the rings of a three-ring binder, eliminating the need for hole punching. Loop stitching works great for educational or reference materials.

These product brochures designed by Hornall Anderson Design Works are bound with loop stitching so that retailers can easily place them in their product binders.

PRICING
Beware of Printer Lowballing

Lowballing, or undercutting the prices of other printers, is a common practice that printers use to snag a client. Be prepared to be overcharged on a project down the road by a printer who does this. He'll be looking to make up for the loss he incurred on his lowballed job when you're least likely to expect it.

➤➤ ## COLOR

Creating Color on a Shoestring

You can create a third color on a two-color job by overlapping tints of each color. Converting a halftone to a duotone creates an even greater range of color variation.

In his newsletter design for the New Orleans Symphony's newsletter, designer Tom Varisco uses a duotone to create additional colors from a two-color run.

PAPER FINISH
Choose the Right Varnish for Your Job

Varnish does a great job of adding a glossy sheen to photographs and other visuals you want to high light or dulling areas like text that benefit from a low-glare surface. But varnish can do much more. Nontoxic varnish can serve as a barrier between a package and the food it contains. Nonslip varnish can help keep stacks of brochures from sliding off a slanted surface. Non-yellowing varnish can be used on jobs that will have a long shelf life. Wax-free varnish can be overprinted. Scuff-resistant varnish can protect covers from rough handling.

Be sure you talk to your printer about how the piece you've designed will function and ask for his advice for varnishes or other finishing techniques that will help protect your work and keep it looking fresh.

PRINTING
Work and Turn vs. Work and Tumble

Know what impositioning a job involves and how it can affect four color on press. With sheetfed offset, a work-and-turn job involves printing a sheet with your job impositioned front and back on one side and turning it so that it prints left to right on the opposite side. On the other hand, a work-and-tumble imposition, where your job is impositioned front and back on one side and then flipped head-over-heels, gives a totally different in-line makeup. Each can affect the way ink is laid down and the resulting color on your job.

COLOR
Fluorescents Help Brighten Four-Color Images

If you're afraid brightly colored papers will dull your four-color images, try adding fluorescent magenta and/or fluorescent yellow to your regular process magenta and yellow inks. Because fluorescent inks are more opaque, these colors will appear more intense than regular process colors. Ask your printer to add at least 10 percent fluorescent ink and be willing to do a press check to experiment with adding more fluorescents, if necessary.

➤ ➤ # PRINTING

Printing Barcodes

When printing on a web press, it's important to make sure the bars run vertically across the rollers. If they run horizontally, the ink may spread, which can make the bars completely unreadable.

Excerpted with permission from "Working Smart," *Step-By-Step Graphics*, Vol. 15, No. 4, July/August 1999

When barcodes are printed, their orientation on press can have an impact on how easily they're read.

COLOR

Speccing Screen Tints: Not a 50/50 Proposition

When printing color tints, stay away from halftone screens of 50 percent. At 50 percent, dots and white space are of equal size, causing halftone dots to barely touch at the corners. This can often cause a bridge of ink to occur between dots, dramatically altering the amount of ink gain on press and changing the overall hue or value of the color.

INK

Tips for Achieving Smooth, Solid Ink Coverage

- When trying to achieve smooth, solid coverage of a match color on press, changing the rotation of the inks in the fountain may help. Inks closer to the end of the press tend to lay down more smoothly since they pass through fewer rollers and blankets.

- For large areas of solid coverage with a match color, two hits of a color help to avoid blotchiness and streaking and reduces hickeys. Some printers prefer to run a tint percentage of the color, or a weakened, "thinned out" version of the color underneath 100 percent of itself.

- If you're working with process colors, you can achieve a really rich black by laying down a process tint combination beneath 100 percent black. Forty percent cyan works well or a combination of 40 percent cyan, 40 percent magenta and 40 percent yellow. This works especially well if you want an extra dark black. You can also get better solid coverage under a match color on a six-color run if you run the match color's process tint combinations beneath the solid match color.

Robert Sternau, Toppan Printing Company America, Inc., New York City

➤➤ PAPER FINISH
Is Varnish the Best Option for Protecting Your Work?

Beyond standard varnishes that are applied in-line or as aqueous coatings, there are other options for protecting your work. UV-cured varnishes provide an even harder protective surface than traditional varnishes. And if you want a really hard finish that will protect against dirt and spills, consider laminating your piece. Although more expensive than varnishing, laminating is a great option for book covers, menus and other items designed to be used over time.

➤➤ COLOR
Add a Fifth Color for True Solid Color on a Four-Color Run

You may have difficulty achieving true and consistent color by running a solid color as a combination of three or more process colors, especially when running light colors or neutrals. Even though it will require a fifth color, it's best to specify a match color instead.

Trish Wales, Sappi Fine Papers North America, Landover, Maryland

➤➤ INK
Achieving Even, Solid Coverage With an Ink Plus Varnish

To smooth out a large solid area while running a varnish in-line, tint the varnish with the same color ink you are trying to smooth. This is like getting a second hit without the extra unit. Be aware that if you were running a flood varnish, new plates will need to be made, with knockouts of image areas you don't want tinted.

Excerpted with permission from "On Press With Success," a joint project between Strathmore Paper and Wright Communications. Available free from Strathmore Paper. (800)423-7313

➤➤ PAPER FINISH
Don't Use Just Any Matte Varnish

Matte varnish is often used to help prevent fingerprints on solid covers, soften reflective glare on text and prevent ink from scuffing. However, scuffing can occur, and when it does, it will appear as shiny patches against solid, matte areas. To prevent this, ask your printer to use the hardest varnish available.

PAPER FINISH

Use Varnish to Protect Against Fingerprints

When I took this New Year's self-promotional greeting card to my printer, the large solid areas of red and metallic gold ink presented a potential problem—fingerprints showing up when the piece was handled, a common occurrence with dark-colored inks and metallics. To help prevent this from happening, both sides of the card were coated with a dull varnish applied in-line as an additional color.

Angela Jackson, Studio J, North Highlands, California

A coating of dull varnish helped to prevent fingerprints from marring the smooth, solid areas of ink on this New Year's greeting card. Photo: Nina Courtney Photographics

COLOR

Trapping Tip

When running solid coverage of an ink as a background color on a four-color run, it's easier to trap color by creating the background color as a mix of process tints. - Todd Kalagher, Finlay Printing, Bloomfield, Connecticut

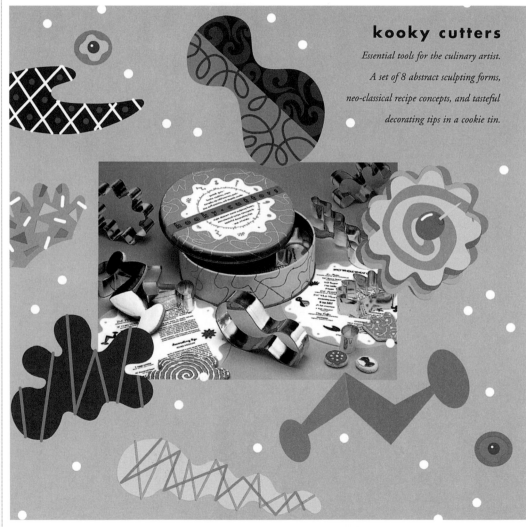

kooky cutters

Essential tools for the culinary artist.

A set of 8 abstract sculpting forms,

neo-classical recipe concepts, and tasteful

decorating tips in a cookie tin.

Magenta was a color common to nearly all of the images on this page, which reduced the need to trap.
(Page is from Higashi/Glaser of New York's "Creation" brochure.)

PRINTING
How to Even Out Background Tints

When printing a four-color publication, you can prevent blotchy, uneven screen tints made from a combination of process colors by doing the following:

- **The fewer colors used the better. Limit yourself to no more than three process colors.**

- **Spec one of the colors for at least 60 percent.**

- **Have your printer imposition your signatures so that nothing but black type prints in-line with your tint.**

PAPER FINISH
There Are Two Sides to Every Paper

On some uncoated papers, there is a significant difference between the paper's felt side and wire side. Often the paper's smoother side is better for heavy solids, screens, color separations and halftones. Choosing the smoothest side for printing solids also helps to prevent cracking at fold lines in a folded brochure. Your printer can do a drawdown, testing ink applied to both sides of the paper you've chosen to determine whether the felt or wire side works best for your project.

Robert Sternau, Toppan Printing Company America, Inc., New York City

COLOR
Engineering Color Into a Barcode

Although black-and-white (black bars on a white background) is the most reliable combination for barcodes, many spot colors can make it through a scanner successfully. Dark shades of blue, brown and green work for the bars, and backgrounds can be printed in yellow, pink, peach, orange or red (most UPC scanners use infrared lights, and to them, even the brightest oranges and reds are invisible). Remember, though, that you must stick to spot colors and use them at 100 percent; CMYK mixes and color tints won't work.

Excerpted with permission from "Working Smart," *Step-By-Step Graphics*, Vol. 15, No. 4, July/August 1999

➤➤ PAPER FINISH
Printing on Porous Stock

When you are screen printing on chipboard or another absorbent sheet, specify a white undercoat or hit of varnish beneath color areas to seal the stock. This simple step will improve the opacity and accuracy of your colors.

Excerpted with permission from "Shortcuts," *Step-By-Step Graphics*, Vol. 10, No. 5, September/October 1994

➤➤ ENGRAVING
Tips for Working With Engravers

Engraving is a great option for achieving a prestigious look. However, this printing technique offers advantages and limitations. Here are some guidelines to follow:

- **Engraving makes use of different inks than litho inks. It's not suitable for four-color process, but match colors can be easily achieved.**

- **Opacity of inks allows for printing light colors on dark-colored papers.**

- **Image reproduction is just as clear as with litho, but photographs and continuous-tone illustrations are etched and not reproduced as a series of halftone dots as they are with offset lithography. This technique may be cost-prohibitive. Image area is also limited to 5 × 8 inches (12.70cm × 20.32cm), the plate size that most commercial engraving presses can accommodate.**

- **Avoid trying to reproduce large areas of color, which can appear mottled or uneven. Instead, consider an outline of your image or a screen tint.**

- **Convert envelopes after they have been engraved to eliminate the debossed impression engraving leaves on the back, or print the address on the flap. To avoid a debossed impression, be sure your engraver prints your envelopes with the flaps open.**

➤➤ ENGRAVING
Engraving and Paper

With engraving, paper is an important decision. Coated stocks tend to crack, so pretesting is important, and laid papers sometimes cause the ink to feather, although the engraver can usually compensate for the problem by adjusting the ink flow or the pressure on the die. Wove stocks handle engraving beautifully. (This information is courtesy of the booklet "Crane's on Engraving," 800/613-4507.)

Excerpted with permission from "Shortcuts," *Step-By-Step Graphics*, Vol. 16, No. 4, July/August 2000

➤➤ THERMOGRAPHY
Tips for Working With Thermography

Thermography combines powdered resin and ink to create a raised impression on paper. It may not be suitable for all printing applications. Here are some tips for designing with thermography in mind:

- Clearly defined line art and type that is 7 points or larger are best for thermography. Halftones and screen tints should be avoided.

- Select a rigid stock with a minimum weight of 20 lb. Any cover weight will do. Avoid heavily textured papers that can trap powder in nonprinting areas.

- Coated or uncoated papers can be thermographed, but uncoated papers contrast nicely with the glossy surface of thermography. Thermography will also work on vinyl and polyester.

- Stay away from large, solid areas of color—they can blister.

- Trimming a thermography bleed requires die cutting. Guillotine trimming may crack the thermographed area.

➤➤ # FOIL STAMPING

Guidelines for Designing With Foil Stamping

Foil stamping is a great technique for achieving flat, glossy color on a dark paper or a solid metallic. Here are some design considerations to keep in mind:

- Cover stock, 20–24 lb. writing paper and 50–70 lb. uncoated text are recommended for foil stamping. Uncoated paper also contrasts nicely with the smooth gloss of foil stamping.

- Coated papers, which are less porous, are rarely foil stamped because of the possibility of gas trapping between the foil and surface coating.

- It's easy to create a foil-stamped comp of your idea. Foil stampers can provide samples of leaf or foil colors on your chosen stock. Companies that sell specialty stocks for your laser printer also carry foils that you can fuse to paper.

- Foil stamping works well with embossing because it will stretch over the relief image.

- Foil-stamped paper generally will pass through a laser printer without puckering or bubbling, but it's best to test a sample first to be sure.

- Placing foil-stamped/embossed art too close to the edge of a sheet may cause the paper to wrinkle or pucker.

- Foils may not adhere properly to papers that have been coated with varnish or inks with wax content. Make sure your printer is using wax-free inks.

- Foils tend to spread or fill in across narrow spaces. To prevent this, avoid tightly kerned and fine type or placing design elements too close together.

- Be aware that different types of foils exist for a variety of jobs. Some types are appropriate for fine line work, while others work best for covering large areas. Make sure your printer is using a foil that is appropriate for your job.

- When doing a press check, make sure that foil-stamped edges are sharp and square. Make sure that no areas are peeling or appear to be scuffed. Check for color consistency from the beginning to the end of the run.

COLOR
Reproducing Match Colors With Process Colors

Many (but not all) match colors can be created by combining tints of process colors. When combining process colors to create a match color, here are some basic considerations to keep in mind:

- Lightest colors are the hardest to match. The darker or dirtier the color, the easier it will be to match.
- Colors that contain transparent white are often difficult to simulate with process colors.
- Colors that are close to a process hue are easiest to match.

INK
Metallic Inks

When printing with metallic inks, avoid problems by doing the following:

- Use coarser screens to avoid plugging and globbing in halftones and tints.
- Overprint with varnish to protect against scuffing.
- Consider foil-stamping or another finishing technique if the combined cost of printing a metallic with a varnish, on an underlay of an opaque ink, is prohibitive.

PROOFING
Which Color Proofing System Works Best?

Many designers and printers feel that a chromalin match print is the most accurate proof you can get. It's made from negatives. When it comes to accuracy, how can you argue with that? However, recent innovations in digital printing have enabled many prepress services to generate digital prints that are every bit as accurate as a chromalin. Which is best?

The best proofs are the ones your printer can match. If they're honest, they'll tell you that they have a preference for some proofs over others. Ask them what they prefer and, if possible, give them what they like.

➤➤ **EMBOSSING**

Achieving Trouble-Free Embosses

To avoid problems with an embossed design, follow these guidelines:

- Embossing tends to smooth out a paper's surface. Take advantage of this by contrasting the smoothness of an embossed image against a roughly textured paper.

- Avoid printing type over the reversed, embossed image on the opposite side of your sheet.

- Specify a beveled emboss for sharp details or pointed edges. Bevels allow for a deeper emboss without tearing the paper.

- Specify brass or steel dies for long runs or a sculptured or multi-level emboss. Magnesium dies are a more cost-efficient option for shorter runs and simple embosses.

- Images and type should be slightly oversized because the finished image will appear smaller than the original as a result of the beveled or rounded sides of the emboss. Space type to compensate for beveled or rounded edges.

- Rules should be at least 2 points thick to compensate for beveling.

- Space type out to provide room for beveled edges.

- Small type and type with pointed serifs should be avoided. They may cause distortions in the paper.

- Keep designs away from the extreme edges of the sheet to avoid wrinkles and puckers.

- Make sure the emboss is imprinted with the grain of the paper. A cross-grained emboss can sometimes cause paper to crack or tear.

- When doing a press check, hold paper up to the light to check for pinholes and ruptures in the paper. Make sure edges are crisp and square. Check to be sure depth of emboss is appropriate for overall design.

INK
How to Prevent Ink From Cracking on Folds

When printing solid colors on coated stock, ink often cracks at fold lines. Here are some tips that often help prevent this:

- Don't expect a piece with two hits of ink and a varnish not to crack. The less ink you use, the less likely it will crack at the fold line.

- Have your printer print the piece so that the folds are in the direction of the paper's grain.

- Score wherever there is to be a fold. Letterpress scoring is particularly effective in guarding against cracks on coated papers.

Reprinted with permission from *Graphic Designer's Guide to Faster, Better, Easier Design & Production*, by Poppy Evans, published by North Light Books

FOLDS
Plan Ahead When Designing a Barrel-Folded Brochure

Ensure that a barrel-folded brochure will fold within itself properly by planning it so that when the brochure is folded from the outside panel to the innermost one, each segment is slightly smaller than the previous one. Allowing a difference of $1/16$ inch (0.16cm) from one panel to the next is usually sufficient, but some printers will ask for $1/8$ (0.32cm) inch, depending on the bulk of the paper you use. Consult with your printer to see what he prefers before setting up the layout for your piece.

PAPER FINISH
Dull or Gloss Varnish: Which Works Best on Coated Stock?

If you are varnishing in-line and want to achieve a noticeable surface separation between gloss and dull elements, start with gloss paperstock and dull varnish the background. The difference is more apparent if you dull varnish a gloss sheet than if you gloss varnish a dull sheet.

Excerpted with permission from "On Press With Success," a joint project between Strathmore Paper and Wright Communications. Available free from Strathmore Paper. (800)423-7313

COLOR
Matching Color on Different Types of Paper

A color printed on white coated stock can appear very different when printed on a white uncoated stock. To keep color consistent, adjustments may need to be made on press to compensate for these color shifts, including the addition of fluorescent inks.

FOIL STAMPING
To Knock Out or Not

When you foil stamp a printed piece, is it better to stamp the foil over the inked area or knock out the inked area that is going to be covered with foil? According to foil stamp experts, it's better to overstamp the ink without knockouts, as long as the printer uses wax-free inks. Knocking out the area behind a foil stamp creates registration and trapping issues that can be easily avoided by inking the entire area behind the foil stamp.

However, there are exceptions. If you're stamping a large solid area, you may want to knock out the foil-stamped area to avoid trapping any gases in the ink or overstamping wet ink. Overstamping wet ink can cause the foil to "pick," making it difficult to achieve clean edges on the foil stamp design.

INK
Help Prevent Ghosts

An effect called mechanical ghosting can occur when ink is unevenly deposited in a particular area. This can sometimes be caused by the layout of the signature, but at other times it is a function of the design. For example, a flat color border on four sides of an image will use up more ink on the two vertical sides as it goes through the press than on the top and bottom horizontal ones. This can cause the vertical portions to be lighter than the horizontal one at the far end of the border.

Excerpted with permission from *The Warren Standard*, Vol. 5, No. 1

TEXT
Take Dot Gain Into Consideration When Reversing Type

Press or dot gain can make reverse type smaller. It also makes the empty spaces between letters larger. To compensate for this, make type bolder than you would if it were to run as a positive and kern letters more tightly. Also remember that typestyles with thin/thick strokes and delicate serifs are more likely to present problems when they're reversed than sans serif fonts with even strokes.

PAPER FINISH
Aqueous Coating vs. Varnish

Want to keep colors vibrating and avoid cracking at folds? Seal the ink surface of a sheet of uncoated paper with aqueous coating instead of press varnish. Aqueous coating is thicker than press varnish, which means it can fill in the ridges, bumps and grooves in some uncoated papers. In essence, aqueous coating binds the stock fibers more closely together. It does not require a printing plate and is considered wax-free and environmentally friendly. Unlike press varnish, it won't yellow and it resists fingerprints. You can foil stamp, emboss, glue or imprint over all three types of aqueous coatings: dull, gloss and satin finish.

Excerpted with permission from "The Gospel According to Glen," by Hammermill Papers. Available free from Hammermill Papers. (800)892-5467

➤➤ PROOFING

Press Check Advice

When doing a press check, it's often hard to see if the adjustments you're making are achieving the desired result. Keep approved sheets aside for yourself so you can refer back to them easily. This is especially important on large projects with many forms or signatures that have recurring elements. Also, fold and trim your sheet down to final size. Sometimes problems that aren't noticeable on a flat sheet are visible when facing pages are together.

> Excerpted with permission from "On Press With Success," a joint project between Strathmore Paper and Wright Communications. Available free from Strathmore Paper. (800)423-7313

➤➤ COLOR

Press Checks Are Critical to Accurate Color

If color is critical, do a press check, even if you have to be at your printer's at some ungodly hour and it takes hours for the press operator to finally achieve the color you want. The press operator may assure you he can achieve the color you want, but don't leave until you see and OK with your signature a sheet that meets your color specifications.

➤➤ PRICING

Save Money by Ganging Jobs

- If your client needs a number of similar items—for instance, several brochures for the coming year using the same ink colors on the same stock—advise them that it would be less expensive to print them all at once.

- Identity materials that incorporate a consistent look, such as letterhead, memo and press release forms, can be ganged together as part of the same press run. Your printer can save you money by running all of the components on the same sheet.

- Two jobs using the same ink colors and paper can be run in tandem, allowing you to split the paper and production costs between the two jobs.

➤ ➤ PROOFING

Check Reversed Type Carefully When Doing a Press Check

When doing a press check, take special care to be sure reversed type doesn't fill in. It should be consistent in weight and have crisp, clean edges.

If you think it's hard getting to

Overinking and poor registration can often cause reversed type to fill in.

➤ ➤ DRAWDOWNS

Drawdowns Give an Accurate Representation

To judge how an ink will look on a certain paper or to be sure your spot color will be true to what you expect on the paper you've chosen, ask your printer to make a drawdown. Drawdowns won't show how your job will look on a paper but will give you a representation of how the ink color you've chosen will look. Printers and paper merchants won't charge for a drawdown, but drawdowns will add time to your schedule.

➤ ➤ **PRICING**

Save Money by Ganging Your Holiday Card With Your Printer's

If you have a long-standing relationship with your printer, offer to design their holiday greeting card in exchange for having it serve double duty as your own holiday card. Printers will often want you to showcase their printing capabilities, giving designers the flexibility of using four color, die-cuts and other showy production techniques. Create two versions of the card's interior that include your salutation as well as the printer's so that both can be ganged on the same run.

Stan Brod, Wood/Brod Design, Cincinnati, Ohio

Wood/Brod Design's holiday greeting sends a New Year's message for the new millennium.

➤ ➤ ## COLOR
Adjusting Color On Press

You can affect the weight or density of an individual color by having the printer change the press blanket pressure. Squeezing the plate to the blanket can increase the density of a solid or halftone, but expect to lose some detail in the halftone. Too much pressure can create excessive dot gain, resulting in heavy uneven amounts of color that may be difficult to control. On the other hand, any area of the sheet that is printing consistently light may indicate a low spot in the blanket. In that case, suggest changing the blanket.

Excerpted with permission from "On Press With Success, " a joint project between Strathmore Paper and Wright Communications. Available free from Strathmore Paper. (800)423-7313

➤ ➤ ## COLOR
View Color in the Right Lighting

Make sure the match colors are as you specified. Keep in mind that lighting conditions are critical when reviewing match colors. Different lighting conditions can radically change the look of a printed piece. Always be sure to review color proofs and press sheets in consistent lighting conditions. A calibrated standard viewing station is recommended. This is the only way to ensure that you will get the exact color you want on press.

Excerpted with permission from "On Press With Success," a joint project between Strathmore Paper and Wright Communications. Available free from Strathmore Paper. (800)423-7313

➤ ➤ ## INK
Be Patient: Less Ink Takes More Time

When you're doing a press check and ask for more ink, the press operator will press a few buttons and within a minute, the sheets coming off the press will show this increase. However, keep in mind that asking for less ink requires more time. Although the process is the same, it takes a while, usually a few minutes, for the rollers to become clear of the extra ink.

➤➤ # PRINTING
Tips for Ganging Print Jobs

Running two or more items or jobs on the same print job is a cost-saving option. When ganging jobs, keep the following technical considerations in mind:

- Items on the same print run must be designed so that they work on the same type of stock, although not necessarily the same colored stock. For instance, if you run a job on 11 × 17-inch (27.94cm × 43.18cm) sheets of a particular brand and finish of paper, you can switch to a different color of the same stock without making any adjustments on press.

- Items on the same print run must be designed so that they share the same ink colors, but not the same colors. For example, ganging a black and gold flyer with a black and red one requires a three-color press run. Although a three-color run generally costs more than a two-color run, the money saved in prep and other one-time charges would still result in a savings over doing two separate two-color runs.

- Two jobs can easily be impositioned on the same sheet of paper. For instance, a 35 × 45-inch (88.90cm × 114.30cm) sheet of paper can trim down to eight 11 × 17-inch (27.94cm × 43.18cm) sheets, sixteen 8½× 11-inch (21.59cm × 27.94cm) sheets, or a combination of both.

- When impositioning two four-color jobs on a single sheet of paper, position four-color image areas so that they are separated by areas of little ink coverage.

➤➤ # COLOR
Check Solids and Neutrals When Doing a Press Check

When doing a press check, locate a relatively large area within the image that has a swatch of color that you can compare with the same area on the color proof. It's also helpful to focus on neutral areas of color, since they're usually composed of all four process colors and any swing in color may prove easier to see.

Excerpted with permission from "On Press With Success," a joint project between Strathmore Paper and Wright Communications. Available free from Strathmore Paper. (800)423-7313

➤ ➤ **PRICING**

Making the Most of Wasted Trim

When one of our clients wanted to announce the birth of their daughter, we designed an accordion-folded announcement that could be printed on a 12 × 9-inch (30.48cm × 22.86cm) sheet of paper. After she had approved the idea, we noticed that almost 40 percent of the sheet would have been wasted after the cards were trimmed. With her permission, we added our own holiday greeting card on the birth announcement run. In addition to designing a card that fit in the remaining area of the sheet, to avoid any extra costs, we came up with a concept that would work with the same fold configuration so the cards could be scored and folded at the same time. Because the birth announcement was a pro-bono job, our client took care of the printing and paper.

Bryan Ewsichek, Graff Designs, Inc., Cincinnati, Ohio

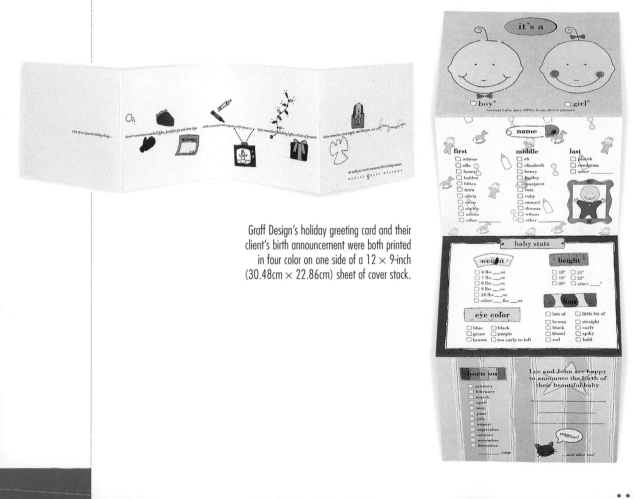

Graff Design's holiday greeting card and their client's birth announcement were both printed in four color on one side of a 12 × 9-inch (30.48cm × 22.86cm) sheet of cover stock.

➤➤ # INK

Common Problems With Inks

When doing press checks, it's important to be able to spot and discuss problems that often occur by having an understanding of the following terms:

- Mottling or sinkage — This occurs when ink doesn't dry properly, resulting in solid areas of color or screen tints that appear speckled or mottled. Mottling frequently occurs on nonabsorbent, hard-coated paper and as a result of bad distribution of ink on the printing plate.

- Picking — White specks appear in solid print areas as a result of small particles of paper that have been "picked off" by ink with too much tack. Other factors that can contribute to picking include cold temperatures and poor paper coating.

- Offsetting or setoffing — Ink or an image is transferred onto the reverse side of the sheet. Offsetting is usually caused by ink that sets too slowly.

- Piling — Blotchy ink coverage that occurs as a result of dirt, lint, powder and dried ink that builds up on the press blanket, plate or cylinder.

- Ghosting — A faint image appears on the printed sheet where it was not intended to appear or as an image that is too light as a result of insufficient ink. Sometimes a "ghost" takes the form of a faint image slightly out of register with the intended image. Other situations include ghosting on the reverse side of the sheet or as a repeat of an image on the same side of a sheet.

➤➤ # INK

Compensate for Dryback

Remember that the ink on the sheet you approve at a press check will be wet and that drawback will occur between the time you approve it and the time the job is dry. Most dark colors tend to dry lighter, while light colors tend to dry the same or slightly darker. Discuss with the printer whether to increase or decrease the amount of ink to accommodate for dryback.

Excerpted with permission from "On Press With Success," a joint project between Strathmore Paper and Wright Communications. Available free from Strathmore Paper. (800)423-7313

➤➤ PROOFING
Don't Rely on Just One Proofing Method

To avoid any unexpected problems, we ask our printer for the following:

- **A blueline dummy for image and page imposition.**
- **Color proofs, when color is critical.**
- **Drawdowns on the stock that we've specced.**

Gordon Mortensen, Mortensen Design, Mountainview, California

➤➤ PAPER FINISH
Watermark Smarts

If the paper you've specced for a letterhead design includes a watermark, be sure your printer knows to run your letterhead design with the watermark reading right-side up.

Trish Wales, Sappi Fine Papers North America, Landover, Maryland

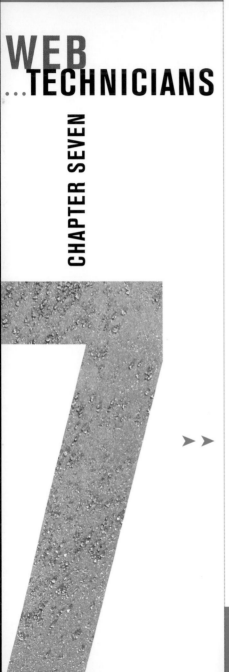

WEB
...TECHNICIANS

CHAPTER SEVEN

➤ ➤ Technical tips plus general advice from Web experts

on how to prepare Web designs and develop working

relationships with technicians in the ever-changing

field of Web design.

MINI-INDEX

PREPARATION

➤➤ ## COLLABORATION
Write a Detailed Contract Before Beginning a Web Design Project

Because Web design is so new, it's hard to define where the responsibilities fall. It's important to delineate at the start of the project who does what. Clearly define, in writing, what your responsibilities and your client's and site engineer's are, right down to who will enter data in the database. Otherwise, you may find yourself up late at night completing a project you felt was already done. Take into consideration as well that Web projects are dynamic. Unlike print projects, which are put to bed after they've gone to press, Web sites are an ongoing project. Define, in writing, what constitutes the completion of the site and that any additions or functional changes during the production phase of the project should be considered a new version and billed separately.

Jane Lindley, Super Web Girl, Seattle, Washington

➤➤ ## DESIGNING
Go for the Sale: Designing an Effective E-Commerce Site

The key criteria for building an e-commerce site include easy navigation and search capabilities. A good e-commerce site gets inside the head of the user to determine how to best create search options for potential buyers. Design should take a back seat to the product. Text should be succinct and informative.

Condensed with permission from "Site Construction 101," by Lisa Baggerman, *HOW* magazine, August 2000

➤➤ ## COLLABORATION
Maintain Contractor Files as a Record of Your E-Mail Correspondence

If you're using virtual assistants or contractors on a project, keep all of their e-mail, as printouts or digitally, filed by contractor for easy access in case there is a misunderstanding about what's been agreed upon or completed. Disagreements can be resolved quickly and painlessly if there is proof of what was agreed upon.

Jane Lindley, Super Web Girl, Seattle, Washington

➤ ➤ # DESIGNING
Space vs. Content

On the Web there's very little space—about sixty square inches on a typical screen, less with the "chrome" of the operating system and the browser. To get the branding, the navigation buttons, the advertising and maybe even some content on this space is pretty hard. Most Web sites opt to spill over the bottom or sides, which causes scrolling. Everyone knows, no one scrolls. Instead, use one screen at a time, but change the content frequently. The Web isn't a reading medium, but presented in short takes, users will read. Just make it easy for them.

Condensed with permission from "Web-Design Dilemmas," by Roger Black, *HOW* magazine, August 1996

➤ ➤ # COLLABORATION
Tips for Collaborating Online

- Electronic collaboration works best among people who already work well together. If you can't communicate with someone on a personal level (or have never communicated in person or at least by phone), don't assume he'll immediately warm to your method of e-communication.

- Make sure that all parties involved are not only comfortable with technology but also use compatible systems. One unreadable e-mail attachment or non-native file can ruin your (or your client's) whole day.

- Although almost everyone uses e-mail, this accepted technology has its deficiencies. For example, many mail servers can't handle attachments larger than 5MB.

- Avoid relying entirely on electronic correspondence. The sometimes sterile environment of e-mail messaging can never replace the sound of a friendly voice, even if it's just over the phone. But do learn from your online collaborations when communicating the old-fashioned way. For example, make notes in an electronic file of every important phone conversation and save them in the same way you save your online messages.

➤➤ ## NAVIGATION
Browsing vs. Action

Developers of Web sites want people to go through their whole site. But increasingly we see that users are getting in and getting out fast. They're cherry-picking, not surfing. They arrive at the Internet with a goal. At the very least, they want to find some specific information.

Accept the fact that people don't have much time. Even with the advent of unlimited-access Internet service, only a few people are going to stroll leisurely through your site. Make it easy to find things.

Condensed with permission from "Web-Design Dilemmas," by Roger Black, *HOW* magazine, August 1996

➤➤ ## FRAMES
Keep Interface Consistent on Web Pages

When building a Web site, set up the interface so that it controls the entire site rather than changing it every time you load a new page. You can accomplish this by constructing your site using frames. That way, only new information needs to be uploaded when a person accesses the information on the site, making the site more efficient.

Gregory Wolfe, Gregory Wolfe Associates Inc., Blanchester, Ohio

➤➤ ## DESIGNING
The Box Effect

Let's face it, the Web is square. Our monitors are square, tables are square, frames are square, images are square. It's easy to see how your site could fall prey to the box effect, something I affectionately call "rectanglitis." You can break out of the boxy mode by making images in irregular shapes. Try to avoid boxes whenever possible and your site design will look more open and inviting. - Lynda Weinman

Excerpted with permission from "101 Hot Tips," *Publish* magazine, September 1999

➤➤ ## NAVIGATION
Content Web Sites: Educate, Inform and Entertain

Because it's not necessary for every visitor to access the majority of content on an online magazine or other content-driven Web site, intuitive navigation is essential. Copy needs to be brief for an online audience. The same amount of copy found in print won't fly on the Web.

Condensed with permission from "Site Construction 101," by Lisa Baggerman, *HOW* magazine, August 2000

DESIGNING
Promotional Sites: Online Ambassadors

Promotional sites convey a corporate personality and philosophy. The most important goal is to convey what the organization or company is all about. Navigation is important, but it's not the focus. Use the site design to create a look or atmosphere for the user and to illuminate the content on the site.

Condensed with permission from "Site Construction 101," by Lisa Baggerman, *HOW* magazine, August 2000

➤➤ TEXT
Make HTML Text More Reader Friendly

HTML text generally has leading that appears too tight, making text harder to read. You can add to the leading in a text block if you insert a period instead of a space between words in each line of text, make it a larger point size and color it the same as your background. The period can't be seen, but because it's a larger point size, text leading will automatically adjust to accommodate the larger size. Be sure you insert it toward the left side of each line so it won't interfere with line breaks.

Gregory Wolfe, Gregory Wolfe Associates Inc., Blanchester, Ohio

➤➤ ADOBE PHOTOSHOP SHORTCUTS
Make Web Buttons Uniform

If you want to quickly lift portions of a photo or pattern fill for button backgrounds and want to make sure the buttons are all the same size, use Photoshop's fixed-size selection marquee. Choose the Marquee selection tool and double-click it to open the Marquee Options palette. Choose Fixed Size from the Style pull-down menu. Enter the exact size, in pixels, in the Width and Height fields. Now every time you click with the Marquee tool, a presized marquee will appear. You can just copy the contents to the Clipboard and paste the contents of the marquee to a layer. - Janine Warner

Excerpted with permission from "101 Hot Tips," *Publish* magazine, September 1998

➤➤ DESIGNING
Cloak Your Code to Elude Spammers

Include your e-mail address in a Web page and watch the amount of junk e-mail you receive start to rocket. That's because a number of companies run search-engine-like software to mine Web pages for valid e-mail addresses, which they turn around and sell to spam marketers. The mining software is smart enough to look at the underlying HTML code, so it can grab an actual e-mail address (joe@acme.com) instead of disguised linked text ("e-mail Joe") made with the "mailto:" URL coding convention.

The solution is to cloak your e-mail address by substituting the ISO-8859 codes for each character in your address, just as you're probably already doing for such characters as nonbreaking spaces (). You can find a table of those codes in the back of most Web design books. - Anne-Marie Concepción

Adapted with permission from "101 Hot Tips," *Publish* magazine, September 1999

PORTABLE DOCUMENT FORMAT (PDF)
Optimize PDF Files for Web Publishing

With the ability to share fully formatted files, including fonts, Adobe Acrobat PDF files are ideal for publishing data on the Web. But PDF file sizes can be hefty compared to HTML files. To optimize PDF files for Web publishing using Acrobat, be sure to select Save As and check the Optimize box when saving the file to discard extraneous text and image data. - Daniel Giordan

Excerpted with permission from "101 Hot Tips," *Publish* magazine, September 1998

IMAGE SIZE
Mind the Bytes!

It doesn't matter how good the site looks—if the images are too large, no one will stick around. Spend some time experimenting with Web compression types: GIF and JPEG are the files to master. Remember that GIF stands for "Graphic Interchange Format" and JPEG stands for "Joint Photographic Experts Group." You'll see the GIF acronym contains "Graphic" and JPEG includes "Photographic." That's because GIFs best compress line art and solid colors, while JPEGs best compress continuous tone images.

If you remember these rules, you'll make smaller images. To make the smallest possible GIFs, experiment with using fewer colors and reducing areas of continuous tone in your graphics. To make the smallest possible JPEGs, experiment with different quality settings. Don't be afraid of lower settings; there's a different quality aesthetic on the Web than in print. In print, you strive for the highest quality and need the highest possible resolutions to achieve it. On the Web, you're looking for a balance between image quality and file size.

Excerpted with permission from "Web Workshop," by Lynda Weinman, *HOW* magazine, August 1999

ANIMATION
Animated Backgrounds That Change Colors

With Macromedia's Flash animation as popular as it is, sometimes the simple solutions get overlooked. It's easy to create a background effect that morphs from one color to the next. Simply create an animated GIF as a background tile. I created a small colored tile (36 pixels square) in Adobe ImageReady that animates—or blends—through three colors and back to the beginning. Tip: Choose complementary or related colors for your animated series rather than contrasting colors—the transitions are much smoother and more attractive.

Chris Garland, Xeno Design, Van Nuys, California

Check out www.fuzzilogic.com and watch the background on this site's homepage morph from one color to the next.

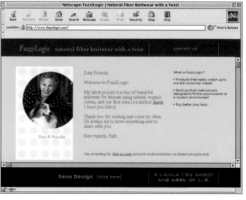

➤ ➤ ORGANIZATION
One Thought, One Message

People often decide whether to keep or delete an e-mail message by reading the first few lines, what they see "above the fold," as that space is sometimes called. If you address another issue further down in the message or add a postscript at the bottom, it's likely they won't ever see it because they may never scroll past the fold. So keep your messages focused. Offer one idea, comment or question per message—two at the most. If you have more to say on other topics, send multiple messages, which makes it easy for people to file them in the appropriate folders.

Excerpted with permission from *Self-Promotion Online*, by Ilise Benun, published by North Light Books

➤ ➤ PREPARATION
Become a Web Master

Are you a master of your own Web site? If so, here's what you need to know, according to Internet Marketing Challenge:

- How do visitors find your site in the first place?
- How many make it past the main page?
- Which page is the most popular?
- How long does the average visitor stick around?
- What is the average number of pages viewed?
- What path do visitors take through your site?
- What links do they use to leave your site?

Excerpted with permission from *Self-Promotion Online*, by Ilise Benun, published by North Light Books

➤ ➤ ORGANIZATION
Keep a Log

Log files are records of all the visitors to your Web site. They tell you where your visitors are coming from, what they're doing on your site, how long they stay, which files they download, etc. This information can help you understand what your visitors want to see, as well as point out navigational problems. Most Internet Service Providers (ISPs) offer access to your log files as part of the monthly hosting fee; they are sometimes sent automatically, or you can go get them. These reports can provide the information in both text and graphic formats. If this data isn't offered by your ISP, there are free services that provide it.

Excerpted with permission from *Self-Promotion Online*, by Ilise Benun, published by North Light Books

• • • • • •

➤➤ ANIMATION
Rollovers

A rollover occurs when your cursor touches a graphic and the image changes. The graphic may transform into something completely different, glow, become embossed or change color. A good rule of thumb is to keep the rollover artwork the same size, even if the shape and size of the content varies. This ensures uniform positioning and registration, critical to most rollover effects. The effect is ruined if the rollover moves unexpectedly because of bad registration.

Excerpted with permission from "Rollover Web Graphics," by Lynda Weinman, *HOW* magazine, October 1998

➤➤ COLOR
Expanding a Web Palette

If you are frustrated with the limitations of the 216 Web-safe colors when you define the background color for a Web site or when you want to use a custom color as a background color (damning the possibility of dithering), create a very small (5 pixels square) GIF from an Illustrator or Photoshop file that has the custom color you want. Specify it as the background in your HTML document, and it repeats to create the illusion of a solid color. - Chris Lona, Bellevue, Washington

Excerpted with permission from "Shortcuts," *Step-By-Step Graphics*, Vol. 15, No. 6, November/December 1999

➤➤ ADOBE PHOTOSHOP SHORTCUTS
Round the Corners of Buttons and Banners

Here's a good way to make buttons and banners with rounded edges in Photoshop. Make a selection with a Marquee tool, then choose Select, Feather and enter a radius that gives you the degree of corner rounding you want. Then convert the selection to a path, save the path and convert it back to a selection any time you need a rounded rectangle. - Janine Warner

Excerpted with permission from "101 Hot Tips," *Publish* magazine, September 1998

TEXT
Online Type Tip

We first create type in Adobe Illustrator and then rasterize it in Photoshop. We still do most of our small text this way even though Photoshop allows you to maintain editable text. This gives us more control over the letter spacing and enables us to clearly see and adjust the fine typographic details. Once in Photoshop and indexed to the Web color palette, we can zoom in to see the obvious defects in the letterforms. We then carefully go in with the pencil tool and electronic eraser and push pixels around to improve the contrast and maintain the original integrity of the letterforms. We are careful, however, not to overdo it. If we push pixels around too much, the curved forms become jaggies. - Jeff Zwerner, Factor Design, San Francisco, California

Excerpted with permission from "Working Smart," *Step-By-Step Graphics*, Vol. 15, No. 2, March/April 1999

IMAGE SIZE
Technology vs. Time

In the effort to enliven Web sites that started off looking a lot like the newsletters of research librarians, developers began heaping on multimedia effects—QuickTime video, Shockwave animation and Java applets. The problem was that the download time turned the Web into the World Wide Wait.

The resolution: Put all your eggs in one basket. One big picture downloads more quickly than several small ones. Make the choice between a snazzy Java navigation bar and an applet that enables a transaction. Don't hope for more bandwidth. Bandwidth, like freeways, will always be relative and finite.

Condensed with permission from "Web-Design Dilemmas," by Roger Black, *HOW* magazine, August 1996

NETSCAPE SHORTCUTS
Get Graphic Dimensions Quick

Working on an HTML document and not sure what the pixel dimensions are for a GIF or a JPEG image and you don't want to open Photoshop just to find out? Drag and drop the image into a Netscape window and look at the title bar. - Anne-Marie Concepción and David Blatner

Excerpted with permission from "101 Hot Tips," *Publish* magazine, September 1998

• • • • • •

➤ ➤ ADOBE PHOTOSHOP SHORTCUTS
Make Seamless Tiles for Web Backgrounds

If you want to create a repeating background pattern from a single tile, use this Photoshop trick. Load the image from which you want to make the tile and choose Duplicate from the Image menu. In the duplicate, choose the Marquee tool and Shift-drag a selection (to restrict the selection to a square) that encloses the pattern you want to use. (A square between 32 and 64 pixels works pretty well.) Choose Image, Crop. Now you have a file that is a tile. Choose Filter, Other, Offset, and specify horizontal and vertical amounts that are half the width of your file, and click OK. Look carefully, and you'll see a seam that divides the tile into quarters. Choose the Rubber Stamp tool and paint out the seams by picking up texture from either side of the seams. Save the file as GIF or JPEG.

Excerpted with permission from "101 Hot Tips," *Publish* magazine, September 1998

➤ ➤ IMAGE SIZE
It's So Phat!

Good compression is the key to good images. Many excellent applications make this task easy, but two simple rules should guide every image impression. First, images with a lot of continuous tone, such as photographs, will almost always be smaller and look much better when saved as JPEG files. Second, graphics with a lot of solid and flat color, such as logos, cartoons and illustrations, will almost always look better and be much smaller when saved as GIF files. Follow these two basic principles, and your site will download more quickly. - Lynda Weinman

Excerpted with permission from "101 Hot Tips," *Publish* magazine, September 1999

➤ ➤ DESIGNING
Make a Tiled Gradient Background

Sometimes it's nice to have a gradient for a background on a Web page, but you don't want to create a single graphic that encompasses the whole background because it would take forever to load. As long as you create a vertical gradient, no problem: make a new file in Photoshop about 16 pixels high and 1024 pixels wide, and fill it with your gradient.

Be sure to hold down the Shift key while dragging the gradient brush so that the gradient doesn't slant. Save the gradient as JPEG and use it as a background tile on your Web page. Because background images are repeated, your JPEG image will fill the page, creating the illusion of a solid image, but because it's long and narrow and not a full-screen-size image, it won't take forever to download. - Janine Warner

Excerpted with permission from "101 Hot Tips," *Publish* magazine, September 1998

TEXT

Dress Up Bulleted Text

Most publishing pros avoid creating type using character style menus for outlines, shadows and so forth because these effects work so badly at high resolutions. But you can use them to good effect for onscreen presentation. Tired of old-fashioned bullets for your bulleted lists? Try an outlined, drop-shadowed degree mark, created by pressing Shift/Option/8 (Alt/176), or a lozenge, shadowed or not (Shift/Option/V or Alt/224). - James Felici

Excerpted with permission from "101 Hot Tips," *Publish* magazine, September 1998

Some alternatives to traditional bullets:

○ An outlined bullet

● A degree mark outlined and shadowed

◊ A lozenge

The rules of print don't apply to the Web. Be creative with the bullets you use for bulleted lists.

➤➤ DOMAIN NAMES

How to Register a Domain Name

InterNIC (www.internic.net) registers domain names and maintains a database of existing names with a .com ending. InterNIC will also do a search of its database for the Web site name you'd like to use to ensure the same name isn't already in use.

➤➤ PROMOTION

The Power of Print

Don't forget the power of print to move your e-enterprise along. One of the best ways to promote your Web design business is through the old standby, business cards. Always have a card—or a stack of cards—with your URL handy. Circulate your business card with your Web site address on it so interested people can see examples of your work.

➤➤ COLLABORATION

Find Work Through User Groups

Designers can freelance their services to Web technicians or Web site development firms in need of design expertise by networking through user groups. It's a great opportunity to market yourself as one half of the Web site development equation.

➤➤ PROMOTION

Promote Your Web Site With an Online Open House

You've just launched a state-of-the-art Web site that you know will impress those who view it. But how do you get potential clients or others to come to your site? Just as you would launch a new business with an invitation to an open house, launch your new site with an invitation to an online party. It's a great way of letting people know your site is up and worth viewing.

Jane Lindley of Super Web Girl invited clients to her new site by sending out a printed invitation, shown on the next page.

SUPER WEBGIRL

You're Invited!

For: An on-line launch party
When: Today (all day)
Where: www.superwebgirl.com
Attire: Come as you are
RSVP: jane@superwebgirl.com

WEB DESIGN THAT WORKS

Designer Jane Lindley wanted all of her clients to know she had branched into Web design by bringing them to her site. She got their attention and attracted them to her site with this clever pop-up invitation to an online launch party.

➤➤ COLLABORATION
Keeping Current

Web designers and their site engineers need to stay current on a variety of topics that affect the Web (HTML, XML, databases, video animation, etc.). You'll probably benefit from organizing a small group of Web professionals who specialize in different areas and then meet at least once a month to keep each other current. You can distill much more pertinent information this way, in a short period of time, than you can by reading volumes of magazines and e-zines. A support group can also help to share the load if you land an especially big job.

Jane Lindley, Super Web Girl, Seattle, Washington

➤➤ IMAGE SIZE
Photoshop Thumbnails Won't Bog Down Your Site

If you've heard that turning off thumbnail previews in Photoshop will minimize the size of your JPEG graphic files, think again. When these graphics are uploaded to your Web host as raw data, the thumbnail image is stripped away. So go ahead and make thumbnails. It won't matter in the long run.

➤➤ DESIGNING
Link to Success

Strategic links on a Web site can do wonders for your business. Multiple linking relationships provide a network of "good connections" that make it easier for you to extend your reach to new prospects, expand your market and grow your business. Links can do three great things for your online venture:

- **Increase traffic. By exchanging links with reputable industry sites, you create more opportunities to be seen online. Links also allow you to build bonds with sites that may have more exposure and stronger connections than yours to the markets you're after.**

- **Boost your credibility. Links from the Web sites of respected colleagues are the equivalent of online endorsements, which is essential in a place as anarchic, unstructured and vast as the Internet.**

- **Add value to your Web site. By offering your visitors links to resources, your Web site will be perceived as a valuable one, and people will bookmark it and return in the future.**

Excerpted with permission from *Self-Promotion Online*, by Ilise Benun, published by North Light Books

IMAGE SIZE
Cache Your Pics

Most Web designers know that if a browser has downloaded an image from a Web site once, it will be cached onto the viewer's hard drive so that if the image is used again within the site, it will appear instantly without having to download again. This can be used to your advantage if you have a large graphic, such as an animated GIF, that you want to appear quickly. Insert the graphic on the page previous to the one where the graphic will appear and set its height and width to zero. Although the graphic won't appear on this page, when the viewer goes to the next page, it will display quickly because it's already been downloaded. A word of caution when using this trick: You have to be sure the viewer will stay engaged in the preload page long enough for the graphic to completely download. So try to use it on pages where there's lots of interesting text to engage your viewer.

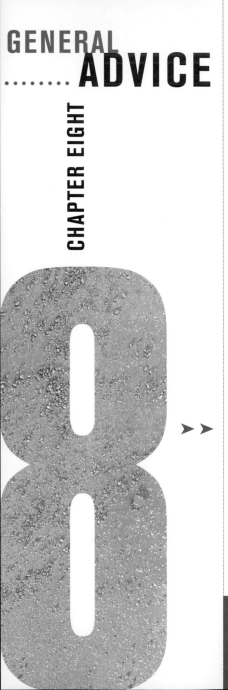

GENERAL ADVICE

CHAPTER EIGHT

8

➤➤ A collection of tips and ideas to help you work more

efficiently plus advice on how to make the most of vendor

relationships in general.

MINI-INDEX

• • • • • •

➤➤ VENDORS
Consider Nontraditional Vendors for Hand-Assembled Jobs

We use vendors like Beacon Foundation, a workplace for mentally and physically challenged adults, for hand assembly of three-dimensional items and boxed gifts. Our clients benefit from a unique piece, assembled at a reasonable price. The workers achieve a sense of accomplishment from getting paid for a job well done.

Jackson Boelts, Boelts Bros. Associates, Tucson, Arizona

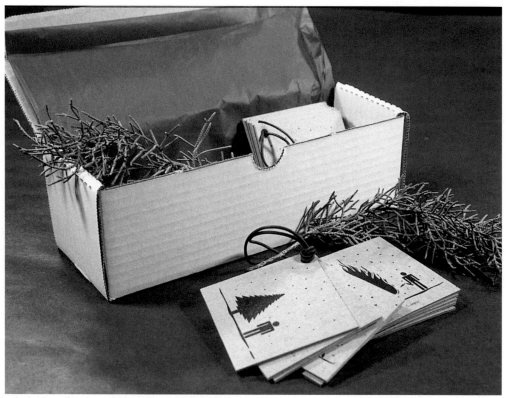

This holiday self-promotion for Boelts Bros., which includes a hand-bound booklet and an evergreen branch, was hand assembled by Beacon Foundation, a workplace for mentally and physically challenged adults.

➤➤ COLLABORATION
On Working With Other Creative Professionals

Be a dream releaser.

Scott Hull, Scott Hull Associates, Inc., Dayton, Ohio

➤➤ POSTAL STANDARDS
Take Special Care When Designing Business Reply Mail

When designing business reply mail that will be returned in a window envelope, take special care to ensure that the piece will fit and that all address information, including barcodes, will show through the window after the piece is folded and enclosed.

➤➤ POSTAL STANDARDS
Postal Regulations for Business Reply Mail

To avoid the extra postage involved in mailing a business reply card that doesn't comply with United States Postal Service guidelines, be aware of the following:

- A postcard falling within the 3½ × 5-inch (8.89cm × 12.70cm) to 4¼ × 6-inch (10.80cm × 15.24cm) size limit will cost you regular postcard postage, as opposed to a higher rate if it's larger. If your card is riding at the bottom of an 8½ × 11 (21.59cm × 27.94cm) or 8½ × 14-inch (21.59cm × 35.56cm) self-mailer, it's worth the extra cost to add an L-shaped perforation, rather than pay the extra postage required on an oversized card that would result from a straight-across, tear-off-at-the-bottom perforation.

- Make sure the stock for your business reply response card complies with USPS weight standards for a postcard. It must be printed on bristol board or card stock that has a basis weight of 75 lb. and a thickness of at least .007 inch (0.018cm) and no more than .0095 inch (0.024cm).

➤➤ COLLABORATION
Solution-Side Thinking

- Identify the problem.
- Team up with another person.
- Don't judge each other's thoughts.
- List what came to mind.
- Set a deadline.

Scott Hull, Scott Hull Associates, Inc., Dayton, Ohio

➤➤ ## COLLABORATION
Remember the Golden Rule

Treat everyone the way you'd like to be treated. The pace of business these days sometimes precludes that.

Allan Comport, artists' representative, Washington, D.C.

➤➤ ## COPYRIGHT
Don't Let Others Rip Off Your Work—Register Your Copyright

The easiest way to register your copyright these days is through the United States Copyright Office's Web site at www.lcweb.loc.gov/copyright. From the homepage, under Publications, click on Forms and look under Download Forms. The VA (visual artist) form enables you to register photographs, illustrations, designs or artwork. Two VA forms are available: 1) the short-form VA, for the creator and owner of the work, and 2) the standard VA form, which can also be used by creator/owners, but is best for work-for-hire situations or for registering a copyright that has been transferred to you. Both forms can be downloaded with or without instructions.

Excerpted with permission from "Thou Shalt Not Swipe," by Jean S. Perwin, *HOW* magazine, June 2000

➤➤ ## HEALTH ADVICE
Avoid Repetitive Strain Injuries

Damage from poorly designed workspaces and bad working habits manifests itself in more than one way. Below are the symptoms and causes of some common repetitive strain injuries:

- **Carpal tunnel syndrome — Aching, numbness or tingling in the forearms or hands caused by swelling of the median nerve and/or the tendons in your wrist. Carpal tunnel syndrome often stems from improper mouse use.**

- **Extensor tendonitis — Pain in the outer elbows and along the backs of the forearms and hands—often caused by improper mouse use.**

- **DeQuervain's denosynovitis — Pain in the thumb(s) caused by repetitive stress on the thumb's extensor tendons. This condition is often the result of repeatedly hitting the keyboard spacebar.**

- **TMJ dysfunction — Headaches, earaches and soreness of the tempora mandibular joint (TMJ) or jaw. Often the result of working with the phone tucked under one ear or leaning in toward the monitor.**

- **Lower back pain and neck pain — Chronic pain and muscle spasms caused by slouching, neck craning and sedentary activity over an extended period of time.**

Adapted with permission from "Doin' Your Body Good," by Jenny Pfalzgraf, *HOW* magazine, October 1999

COLLABORATION
Don't Forget the Phone

When contracting with a creative professional, don't try to do all of your business via e-mail. Make the initial contact by phone. Explain what's involved and agree upon what's needed to get the job done and what both parties will bring to the table. Arriving at a creative solution to a communication objective involves spontaneous discussion and getting to know the person you're working with. E-mail stifles that process.

POSTAL STANDARDS
Colored Envelopes and Background Colors Can Raise Mailing Costs

Bulk mail rates offer a considerable savings over regular mail but require printing the face of your envelopes with an address area and barcodes that can be easily read by the United States Postal Service's automated equipment. Check with the post office before considering printing barcodes or addresses for bulk mail pieces over four-color or colored paper. The USPS's postal equipment can't read barcodes or type if the reflectance from their background is less than 30 percent. Your local post office can use a USPS-approved reflectance meter to check your piece to see if your colored background will allow your piece to qualify for automated rates.

ORGANIZATION
An Idea for Keeping Track of Zip Discs

Constant loss of fifteen-dollar Zip discs to vendors prompted our staff to create custom names for each Zip disc in the studio, naming them after body parts such as hand, eyeball, etc. That way, if the disc isn't returned, one of the designer's body parts will be missing. This is all done in jest, of course, but the idea of losing a limb or an organ prompts our designers to be more conscientious about keeping track of and asking for the return of their Zip discs.

Jackson Boelts, Boelts Bros. Associates, Tucson, Arizona

➤➤ PRICING

Billing Tip: Don't Forget to Add a Markup to Vendor Services

Reimbursement by a client to the designer for vendors' fees is a customary trade practice plus a markup for these services, typically 15 to 25 percent, with 16.85 percent being the average. The markup reimburses the designer for supervisory and handling time and insures that all work is done to the designer's specifications and standards for quality.

Adapted from the *Graphic Artists Guild Handbook: Pricing & Ethical Guidelines*, 11th edition, published by North Light Books

➤➤ POSTAL STANDARDS

Avoid Mailing Problems by Complying With USPS Standards

To assure proper handling and speedy delivery of mail, make sure that placement of envelope type and graphics are in compliance with the following United States Postal Service recommendations:

- The return address should run parallel to the address line, not parallel to the short edge of the envelope.

- The space below and on either side of the delivery address line should be clear of all non-address printing. Return addresses or other print that falls into this area can cause mail to be misdirected and delivery delayed.

- The return address should fall within the top one-third of envelope height, in the left half of the envelope, and the bottom edge of return address should fall no farther than 2¾ inches (7cm) from the bottom left-hand edge of envelope.

➤➤ PRICING

Larger Mailings Reap Discounts

Fulfillment services generally offer discounts for handling large quantities. This means that if you use a mailing service, you might be able to realize a savings by merging lists and combining your mailing with another's. Enlist the aid of your printer in finding a partner who is willing to use the same fulfillment house and is interested in combining lists.

TEXT

Type Standards for Packaging Nutritional Statements

Specifications for the nutritional statements that appear on food packaging are very stringent. The United States FDA is very specific about what size and weight type should be.

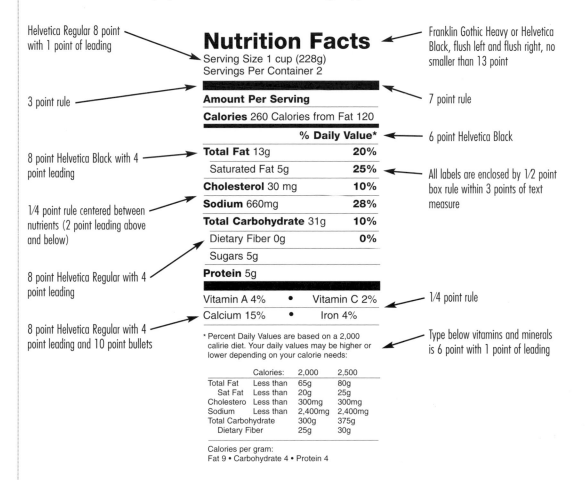

Helvetica Regular 8 point with 1 point of leading

3 point rule

8 point Helvetica Black with 4 point leading

1/4 point rule centered between nutrients (2 point leading above and below)

8 point Helvetica Regular with 4 point leading

8 point Helvetica Regular with 4 point leading and 10 point bullets

Franklin Gothic Heavy or Helvetica Black, flush left and flush right, no smaller than 13 point

7 point rule

6 point Helvetica Black

All labels are enclosed by 1/2 point box rule within 3 points of text measure

1/4 point rule

Type below vitamins and minerals is 6 point with 1 point of leading

Nutrition Facts

Serving Size 1 cup (228g)
Servings Per Container 2

Amount Per Serving

Calories 260 Calories from Fat 120

% Daily Value*

Total Fat 13g	**20%**
Saturated Fat 5g	**25%**
Cholesterol 30 mg	**10%**
Sodium 660mg	**28%**
Total Carbohydrate 31g	**10%**
Dietary Fiber 0g	**0%**
Sugars 5g	

Protein 5g

Vitamin A 4%	•	Vitamin C 2%	
Calcium 15%	•	Iron 4%	

* Percent Daily Values are based on a 2,000 calirie diet. Your daily values may be higher or lower depending on your calorie needs:

	Calories:	2,000	2,500
Total Fat	Less than	65g	80g
Sat Fat	Less than	20g	25g
Cholestero	Less than	300mg	300mg
Sodium	Less than	2,400mg	2,400mg
Total Carbohydrate		300g	375g
Dietary Fiber		25g	30g

Calories per gram:
Fat 9 • Carbohydrate 4 • Protein 4

Follow these guidelines for font and size specifications when setting up nutritional statements.

➤➤ **PROMOTION**

Make Client Gifts of Old Letterhead by Having Your Printer Pad Them

After we moved, we took our out-of-date letterhead to the printer and had them cut off the old address and "pad" them. They make great note pads. We give them to our clients so they have our firm's logo in front of them every time they jot a note.

Jackson Boelts, Boelts Bros. Associates, Tucson, Arizona

Having a printer pad and trim off the address portion of Boelts Bros.' old letterhead yielded impressive note pads that the firm uses as a client gift.

➤➤ **POSTAL STANDARDS**

Sealing Self-Mailers

Seal self-mailers with wafer seals, tabs, glue or even cellophane tape, but never with staples or any clasp-type hardware that can damage postal processing equipment.

➤➤ ORGANIZATION
Dust-Free Monitors

To keep dust from collecting on your computer screen, wipe it with used fabric-softener sheets (the kind you run through the dryer).

Excerpted with permission from "Shortcuts," *Step-By-Step Graphics*, Vol. 16, No. 4, July/August 2000

➤➤ PROMOTION
Overruns Have Promotional Value

Take advantage of overruns, particularly if you're working on a publication and have extra copies of covers or dust jackets. They can be trimmed and printed on the opposite side with promotional copy.

➤➤ DESIGNING
Make Lettering Legible at a Distance for Signage

When designing for signage and billboards, be sure all type can be read from the expected viewing distance. A rule of thumb is to size type so that each letter is one inch high for every fifty feet of viewing distance. Consult the following chart:

Viewing Distance	Type Height
50 ft. (15m 24cm)	1 in. (2.54cm)
100 ft. (30m 48cm)	2 in. (5.08cm)
300 ft. (91m 44cm)	6 in. (15.24cm)
400 ft. (121m 92cm)	8 in. (20.32cm)
500 ft. (152m 4cm)	10 in. (25.40cm)

➤➤ POSTAL STANDARDS
Avoid Extra Postage With the Right Paper

How to make a client angry? By designing a mailer that weighs more than an ounce when your client was planning on paying the standard United States first class rate of 34 cents for a piece that weighs one ounce or less. When postage is important (and it usually is) be sure to have a dummy made with the paper and envelope you plan to use and have it weighed at the post office so you'll know exactly what the postage rate will be.

INDEX

A

Acetate overlays, color, 82
Adobe Photoshop short cuts, 46, 47, 50, 52, 56, 57, 59
Advertising illustration fees, 36
Anchor points, images, 82
Aqueous coating, printers, 135
Author, about the, 5
Auxiliary dictionary, adding words to, 13

B

Backgrounds
 problems in photo graphs, 59
 tints, printers, 127
 websites, 152, 156
Backing up originals, 93
Barcodes, printers, 122, 127
Bidding
 printers, 108
 requests, printers, 101
 size and capabilities of printers, 102
Billboards, 171
Binding
 double wire binding, 105
 loop stitch binding, 118
 methods, 104–105
 perfect bound binding, 104, 113
 plastic comb binding, 105
 saddle stitched, 104
 side stitched binding, 104
 signatures, 115
 signatures accomodated, 101
 spiral binding, 105, 115
 wire-o binding, 105
Blanket pressure, printers, 139
Box effect of website, 148
Brainstorming
 collaboration between writer and designer, 14
 negative statements, 12
Budget limitations, illustra tors, 34, 35
Bulking dummy, printers, 107
Bullets, web technicians, 157

Business cards
 grain, 70
 web design promotion, 158
Business reply mail, 165

C

Checking for missing items, prepress services, 94
City name fonts, 89
Coated and uncoated paper, 68, 72
Coding system, photo graphs, 60
Collaboration
 creative professionals, 164
 Golden Rule, 166
 illustrators, with, 30, 31, 35, 38
 paper merchants, with, 70, 76, 77
 photographers, with, 42, 43
 prepress services, with, 80, 92, 93, 94
 printers, with, 102, 110
 reputations, 38
 solution side thinking, 165
 telephoning, using, 167
 web technicians, with, 146, 147, 158, 160
 writer, with, 14
Color
 acetate overlays, 82
 balance, using Adobe Photoshop gray card, 50
 black-and-white scanned as four-color, 87
 changing, Adobe Photoshop, 46
 checking before finalizing job, 96
 comps, printers, 110
 corrections, 94
 demanding job, printers, 102–103
 different types of paper, 134
 four-color runs, 107, 124
 gradients software, best, 88
 match colors, 131
 montior, misrepresenta tion, 80

overlapping tints, 120
paint feint, 83
process colors, 131
proofs, 93
pumping up, 91
range, scanning, 55
scanning, range of colors, 55
separations, transparen cies, 94
split fountain color run, 114
spot colors, 82
trapping, 126
using same service for reliable color, 81
viewing in right light, 139
web background, 154
Colored paper stock, 66–67
Commissioning, illustrators, 31
Composites, paper mer chants, 64
Conceptualizers, illustrators, 31
Contact proofs, 56
Content, understanding, 15
Contracts, web technicians, 146
Control freak, prepress services, 92
Copy length, 13–14
 cutting, 14, 26
 expanding, 17
 multilingual versions, 19
 typeface, 24
Copyright
 illustrations, 37
 registering, 166
Creative professionals, col laboration, 164
Crooked digital photographs or scans, 50
Current, staying, 160
Custom paper, 66, 69, 72
Cutting
 copy length, 26
Cutting, copy length, 14

D

Dashes, punctuation, 17
Delivering clean files, pre press services, 96
Depth of photographs,

adjusting, 56
Die costs, printers, 108
Digital cameras, 55
Digital color printers, 81
Digital photographs, 43, 53–54
 crooked, 50
 digital capture, 58
Dimensions
 illustration, 35
 photographs, 49
Directory of all files, print ing, 97
Discs, labeling, 94
Display type, 18
Domain names, web techni cians, 158
Dot gain, 134
Double-dot technique, pho tographs, 59
Double wire binding, 105
Drawdowns, printers, 112
Dummy signatures, print ers, 113
Dust and scratches, Adobe Photoshop, 52
Dust-free monitors, 171

E

E-commerce site, web tech nicians, 146
E-mail
 one idea per, 153
 records of, 146
Ease of searching website, 148
Economical layouts, paper merchants, 66
Embossing, 132
Engraving, printers,128–129
Envelopes, 64–65
Estimates, printers, 108
Evaluating, printers, 102
Expanding copy length, 17

F

Fees
 advertising illustration, 36
 illustrators, 32, 34, 36, 38, 39
 writers, 15
Film grain, removing, 59
Flexibility, paper merchants, 72
Flocking issues, paper mer

(RIP), 92
References, printers, 110
Rejection fees, illustrators, 38
Reputations, 38
Reversed type, 22, 88
Rollovers, web technicians, 154

DIRECTORY OF CONTRIBUTORS

➤ Acme Design
240 N. Belmont Pl.
Wichita, KS 67208

➤ Megan Alink
129 Rutherford Ct.
Kanata, Ontario
Canada K2K 1N6

➤ David Beck
4042 Appletree Ct.
Cincinnati, OH 45247

➤ Boelts Bros. Associates
345 E. University Blvd.
Tucson, AZ 85705

➤ Craig Boldman
P.O. Box 18128
Fairfield, OH 45018

➤ Bronze Photography
815 Main St.
Cincinnati, OH 45202

➤ Allan Comport, W/C
Studio Inc.
208 Providence Rd.
Annapolis, MD 21401

➤ dBest
316 West 4th St.
Fourth Floor
Cincinnati, OH 45202

➤ Diversified Screen and
Digital Printing
6 Union Hill Rd.
West Conshohocken, PA
19428

➤ Evenson Design Group
4445 Overland Ave.
Culver City, CA 90230

➤ Finlay Printing
44 Tobey Rd.
Bloomfield, CT 06002

➤ Graff Designs Inc.
2323 Ashland Ave.
Cincinnati, OH 45206

➤ Gregory Wolfe Associates
Inc.
6331 Middleboro Rd.
Blanchester, OH
45107-8320

➤ Hornall Anderson
Design Works
1008 Western Ave.,
Ste.600
Seattle, WA 98104

➤ Independent Project Press
P.O. Box 1033
Sedona, AZ 86336

➤ Iridium Marketing + Design
134 St. Paul St.
Ottawa, Ontario
Canada K1L 8E4

➤ Johnston Paper
1900 River Rd.
Cincinnati, OH 45204

➤ Langton Cherubino Group
Ltd.
853 Broadway, Ste. 1507
New York, NY 10003

➤ The Leonhardt Group
1218 Third Ave.
Seattle, WA 98101

➤ Master Graphics
7245 Canby Ave.
Reseda, CA 91335

➤ Mortensen Design
416 Bush St.
Mountain View, CA 94041

➤ MPI
910 Race St.
Cincinnati, OH 45202

➤ Nina Courtney
Photographics
1616 J St.
Sacramento, CA 95814

➤ Pentagram Design Inc.
387 Tehama St.
San Francisco, CA 94103

➤ Photosmith
39 E. Court St.
Cincinnati, OH 45202

➤ Platinum Design, Inc.
14 W. 23rd St.
New York, NY 10010

➤ Mike Quon
535 Spring St., 5th Fl.
New York, NY 10012

➤ Rickabaugh Graphics
384 W. Johnstown Rd.
Gahanna, OH 43230

➤ Sappi Fine Papers
North America
8201 Corporate Dr.,
Ste. 570
Landover, MD 20785

➤ Sayles Graphic Design
3701 Beaver Ave.
Des Moines, IA 50310

➤ Scott Hull Associates
68 E. Franklin St.
Dayton, Ohio 45459

➤ Studio J
7329 Washburn Way
North Highlands, CA
95660

➤ Super Web Girl
P.O. Box 10765
Bainbridge Island, WA
98110

➤ Thompson Studio
5440 Old Easton Rd.
Doylestown, PA 18901

➤ Tom Varisco Graphic
Designs
608 Baronne St.
New Orleans, LA 70113

➤ Toppan Printing Company
America, Inc.
666 5th Ave.
New York, New York 10103

➤ Treehouse Design
10627 Youngsworth Rd.
Culver City, CA 90230

➤ Vaughn Wedeen Creative,
Inc.
407 Rio Grande, N.W.
Albuquerque, NM 87104

➤ Viva Dolan Communications
99 Crown's Ln., Ste. 500
Toronto, Ontario
Canada M5R 3P4

➤ Werner Design Werks
126 N. Third St., Rm. 400
Minneapolis, MN 55401

➤ Wood/Brod Design
3662 Grandin Rd.
Cincinnati, OH 45226

➤ Xeno Design
6901 Mammoth Ave.
Van Nuys, CA 91405

COPYRIGHT NOTICES